RAYLE

G000069215

THE POSTCARD COLLECTION

MIKE & SHARON DAVIES

AMBERLEY

ABOUT THE AUTHORS

Mike and Sharon Davies have collected postcards for many years and we often visit car boot sales/antique fairs/websites/antique shops in the search for even rarer Rayleigh cards with an ever-increasing cost.

We are indebted to Ernie Lane who passed on his collection when we formed *Rayleigh Through the Looking Glass* in the year 2000. A significant number of Rayleigh residents have kindly donated or lent cards for copying, and the list is far too long to name individually. We are most grateful.

In addition to our extensive archives, we have also sourced some information from other local historian's publications primarily from the local Rayleigh books written by Ernie Lane, Noel Beer and Ian Yearsley. We have also looked at local newspapers, thanks to Eddie Dray, as well as numerous Essex magazine publications over the last hundred years.

All of the profits from this book, as are those from our previous book *Rayleigh Through Time,* will be donated to *Rayleigh Through the Looking Glass,* and the postcards will be on display at the Rayleigh Town Museum that is planned to open early in 2016.

More information is available from www.rayleighhistory.co.uk and www.rayleightownmuseum.co.uk.

First published 2015

Amberley Publishing
The Hill, Stroud, Gloucestershire, GL5 4EP
www.amberley-books.com

Copyright © Mike and Sharon Davies, 2015

The right of Mike and Sharon Davies to be identified as the Authors of this work has been asserted in accordance with the Copyrights, Designs and Patents Act 1988.

ISBN 978 1 4456 4525 4 (print)
ISBN 978 1 4456 4533 9 (ebook)

British Library Cataloguing in Publication Data.
A catalogue record for this book is available from the British Library.

Typesetting by Amberley Publishing.
Printed in Great Britain.

CONTENTS

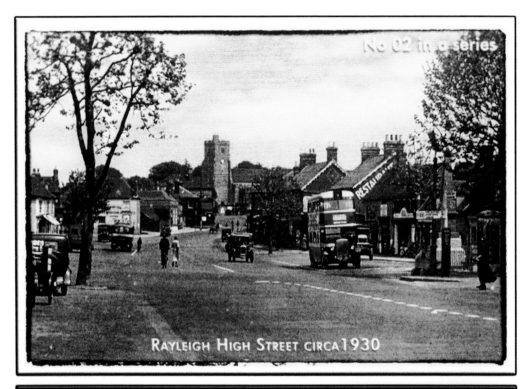

RAYLEIGH HIGH STREET CIRCA 1930

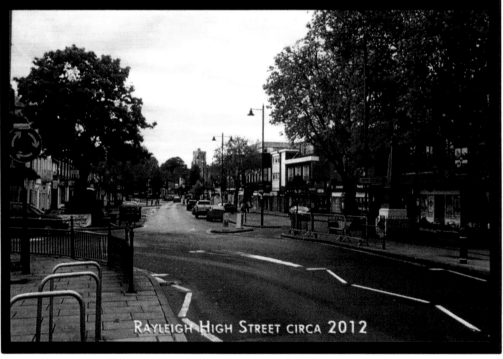

RAYLEIGH HIGH STREET CIRCA 2012

Rayleigh High Street Spanning Eighty Years

INTRODUCTION

A Brief History of Rayleigh

Rayleigh derives its name from the Saxon words '*raege*' (a wild she goat or roe deer) and '*leah*' (a clearing) although there has been a settlement locally since before Roman times.

When William the Conqueror invaded England in 1066, one of his first acts was to order the building of a network of castles. Robert Fitzwimarc who held the 'Honor of Rayleigh' was one of few allowed to retain his land, and it was his son Sweyne who built Rayleigh's Motte and Bailey castle. It is the only Essex castle mentioned in the Domesday Book.

The royal charter for Rayleigh's market dates to 1181 and the royal charter for the Trinity Fair to 1227. Markets, carnivals and community events continue to this day.

On a ridge 240 feet above sea level, the town and its immediate vicinity were an ideal location for windmills. The first documented mention of a windmill in Rayleigh dates from 1300 when King Edward I instructed the Prior of Prittlewell to erect one in Rayleigh. One of the earliest was a watermill in the grounds of the White House, a substantial farm covering hundreds of acres by the Eastwood Road and part of the royal hunting forest used by Henry VIII.

An area of religious devotion since Saxon times Rayleigh's distinctive parish church dates mainly from the perpendicular period (fourteenth to sixteenth centuries). In 1555, two Protestant martyrs were burnt at the stake for refusing to deny their faith, and a memorial was erected to their memory in 1908 at the top of Crown Hill. In the nineteenth and early twentieth centuries, a branch of the Peculiar People religious sect was prominent in town.

Rayleigh was an important town on the Rochford Hundred Adjoining Roads Division of the Essex Turnpike Trust established in 1746. The 'King's Highway' from London passed through Rayleigh along the High Street. Several milestones remain by the side of the road locally as a reminder of those coaching days.

Along the Wickford Road, at the junction with Downhall Road (now the site of the Traveller's Joy public house) once stood a prison as a warning to travellers to behave. On the other side of the road was the gallows.

The first detailed map of Essex (1777) shows a windmill in the Hockley Road and one opposite the Methodist church in what was then called Mill Lane (now Eastwood Road).

In 1793, a second mill was erected close by, and the name of the road was changed to Two Mill Lane. Rayleigh's last remaining mill was built in 1809 and celebrated its bicentennial in 2009.

The advent of the railway in 1889 turned the town from a quiet tranquil village in the nineteenth century (population of around 1,500) to the bustling vibrant town it is today (population of above 35,000).

The first arterial road in this country specifically built for motorised vehicles opened in 1925 (now the A127) and passes the edge of town. Some of the large farms and manor houses became housing estates that are familiar to us today. In the 1920s, locals and visitors were entertained in such places as the Clissold Hall by the Rayleigh Minstrels or watched early black and white films at the Cosy Talkie Theatre. The Regal Cinema opened in 1937. Rayleigh also had its own brewery and several brickfields. Many will recall the speedway stadium near Rayleigh Weir home of the Rayleigh Rockets from 1948 to 1973. In addition, greyhound racing, stock car racing, wrestling and other entertainment took place here.

The castle may have been demolished in the fourteenth century, but the mount, where it stood, by the tower windmill can still be enjoyed today. Many of Rayleigh's well-known landmarks are commemorated by thirty heritage plaques that give details as to the origins of each location. Rayleigh Town Council has a heritage brochure and map showing their locations and origins. Our distinctive Dutch Cottage is one of thirty-eight listed buildings in Rayleigh.

Sources, Selection and Producers

These cards are from the collection of the authors and the archives of *Rayleigh Through the Looking Glass* chosen from over 600 covering the town's history, which dates back over 1,000 years.

Section 1

HIGH STREET

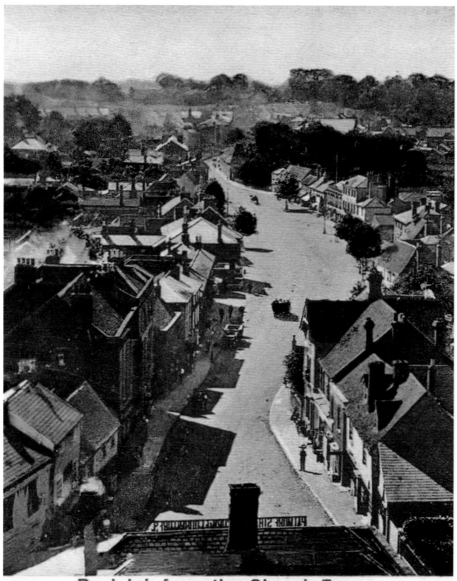

Rayleigh from the Church Tower

Rayleigh High Street from Holy Trinity Church Tower, c. 1910

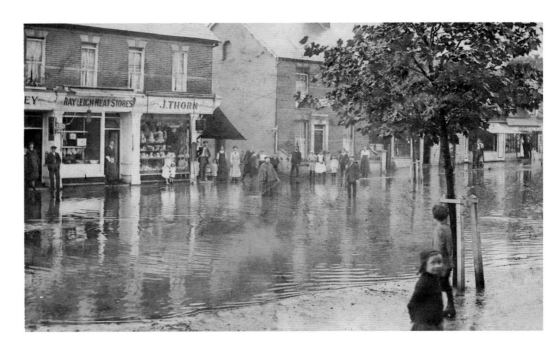

High Street in Flood, 1910 and 1932

Rayleigh High Street often flooded on a regular basis and was an excellent opportunity for local postcard manufactures to produce cards for sale within a few days. The top photograph taken in 1910 from where the Millennium Clock is today shows V. C. and W. Bowen in the centre trying to clear the drains.

The bottom picture, looking towards Bellingham Lane, taken on August Bank Holiday Monday in 1932, shows what we perceive as regular Bank Holiday weather. Before rudimentary drains were installed, excessive water often cascaded down London Hill and Crown Hill. Some roads are prone to flooding even today.

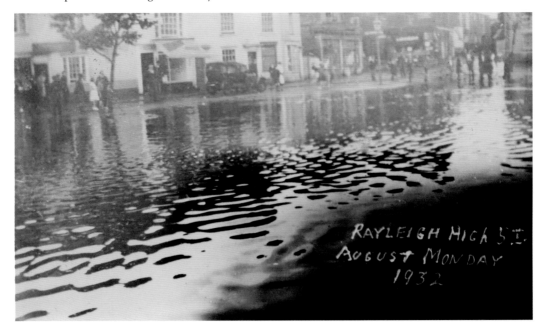

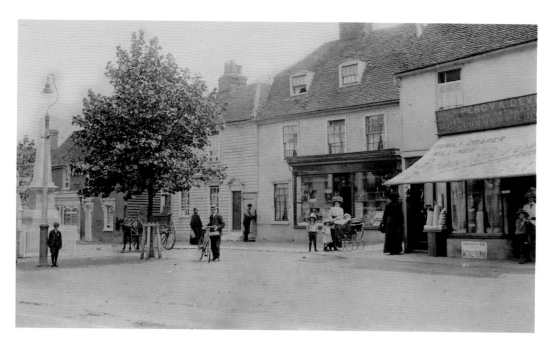

Prominent High Street Traders Hundred Years Ago

Both these postcards date from 1910. Percy Deveson who occupied the oldest secular building in Rayleigh, at 91 High Street, was a family draper and milliner; later, the property was owned by Sansoms, the well-known gentleman's outfitters.

The Thorn family were members of the Peculiar People religious group. The bottom photograph shows his premises by Ernie Lane, the path to Webster's Way car park. Thorns was a hardware shop dealing with 'everything the lady would need for her home'. The room above was the first meeting place in town of the Peculiars before their first chapel in Bellingham Lane was built by Harry Adey early in the twentieth century.

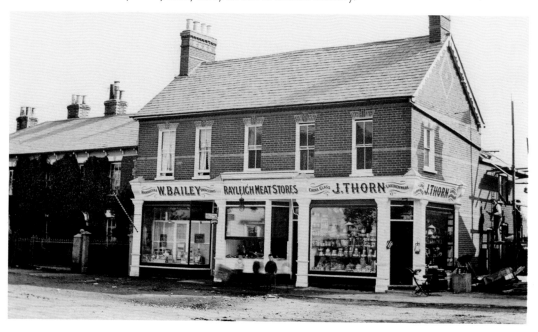

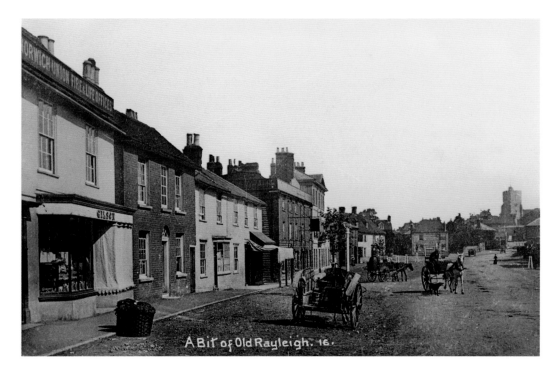

A Bit of Old Rayleigh. 16.

A Bit of Old Rayleigh High Street from Both Sides

One of the prominent grocers in town was Gilson's as seen in the top picture. Mr Gilson's family established the business on this site in the early 1720s. The shop front was totally transformed in the 1920s and later became the International Stores. Typical of Rayleigh High Street for many hundreds of years the Essex weather boarded properties were mainly a mix of residential and residential with businesses on the ground floor. In the bottom picture, we are looking towards where today you will find Martins, Costa Coffee, Boots, Greggs and other prominent well-known High Street retailers.

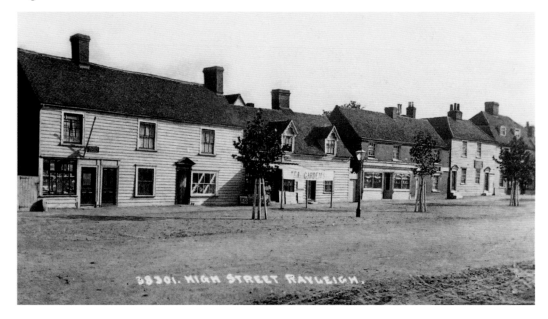

HIGH STREET RAYLEIGH.

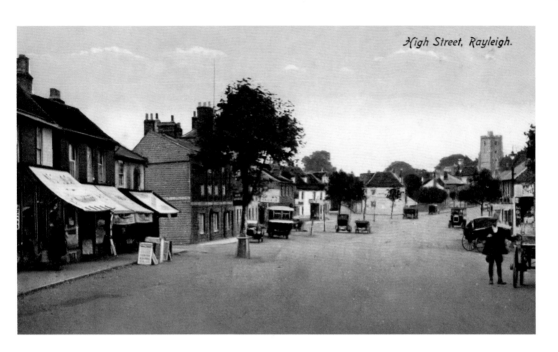

The Wide Expanse of Rayleigh High Street

Both of these cards were originally black and white and were colour-tinted at a later date. Note the state of the roads with compacted earth, granite chippings and open to the extremes of both summer and winter. The eleven trees that were planted at the start of the twentieth century were donated by the well-known benefactor Edward Francis who lived in what is now Lloyds Bank.

In the bottom picture, the archway on the left leads to the stables and forge to the side of the Chequers Pub that stood here until the early 1960s. Currently, the site of the Factory Shop.

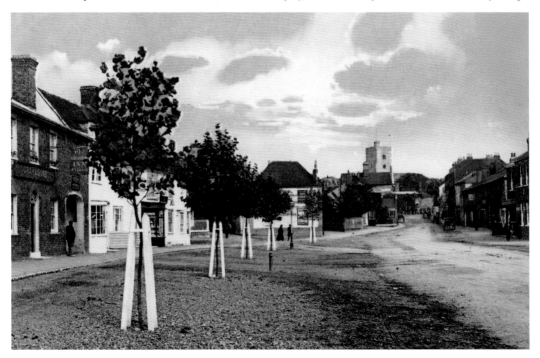

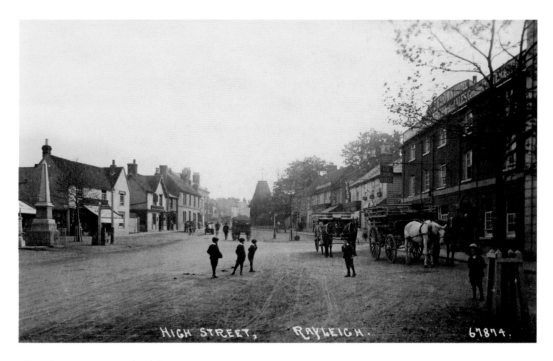

The Changing Face of Public Transport

Two views looking towards the Crown Hotel but from different eras. The top picture dates from the days prior to the First World War when horse power was the dominant form of transport. The Crown Hotel was one of the main coaching inns in town with customers taking refreshment inside before embarking on the four-hour journey along bumpy roads to London. Note the oast house of the brewery in the distance.

Time has moved on in this bottom picture taken in the 1950s with the No. 8 bus taking a breather in the shade, while the conductor relaxes on the seat by the side.

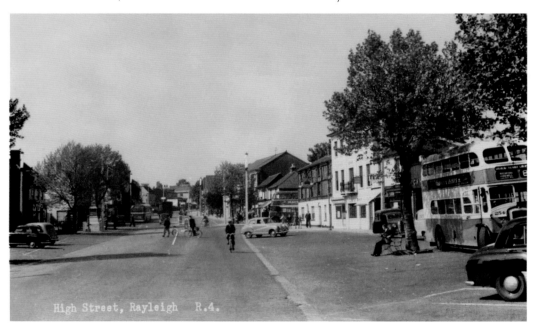

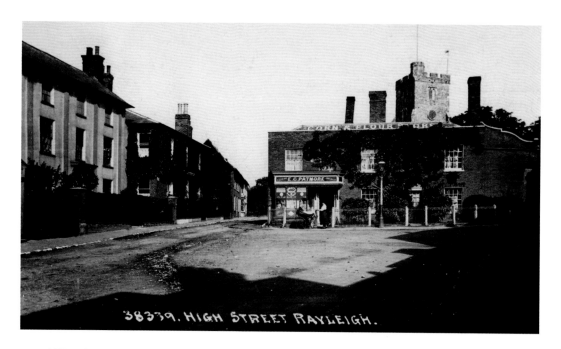

Wisteria House in Front of Holy Trinity Church

These two pictures show Wisteria House in close up. In the top photograph note the house on the left covered in ivy, which was the home for many years of Mr Toes the dentist.

The bottom picture deserves closer inspection. The fence by the side of Wisteria House opens up into the Hockley Road. Mr Wood the butcher has a wonderful window display and outside are hanging what look like fresh rabbits. Notice the little boy in the upstairs window as well as the children outside the pub. Is that Mr Wood at the front door of his shop? This card was posted to France in 1908.

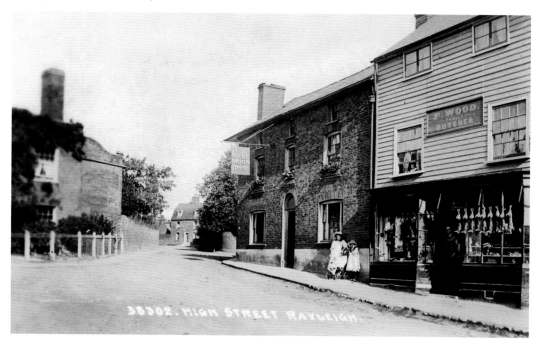

13

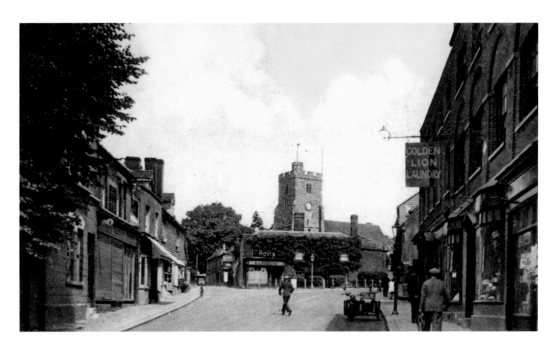

High Street Approaching Holy Trinity Church

Two views looking towards Holy Trinity church. The King's Highway from London joins on the left. Note the very distinctive Wisteria House, the building immediately in front of the church. Patmore's the corn merchants can be seen here, and this building was the first telephone exchange in town when the telephone arrived in 1907. The Revd Girdlestone Fryer, Rector of Holy Trinity noted in his book *Rayleigh in Past Days* published in 1908 that it was a shame that this building spoiled the aspect of his church and that he hoped that one day some enlightened authority would demolish it. Well he obviously had influence because in the early 1930s Wisteria House was demolished.

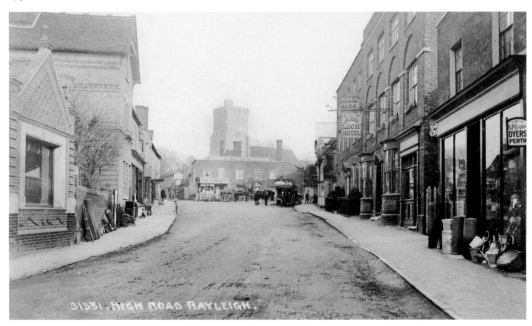

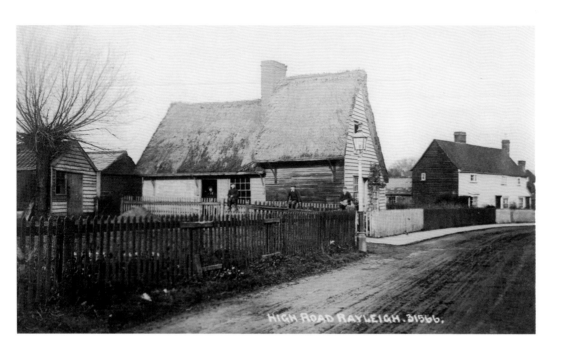

Sandpit Cottage and High Road

The lovely thatched cottage in these next two pictures, taken from both directions, was home to the well-known couple Harry and Jessie Thornton. Originally, the cottage was part of Sandpit Farm and was opposite the Baptist church. It is where the High Street becomes the High Road on its way to the Weir. Jessie gave music lessons at home and in her youth played the violin to accompany the silent films at the Rayleigh Cinema, later to be renamed the Cosy Talkie Theatre that was demolished in 1936 to make way for the Regal Cinema that opened in 1937. The Regal closed in 1973.

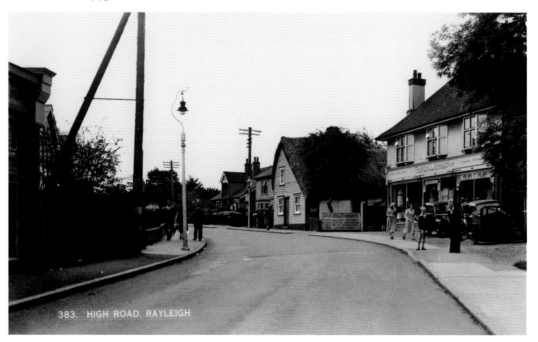

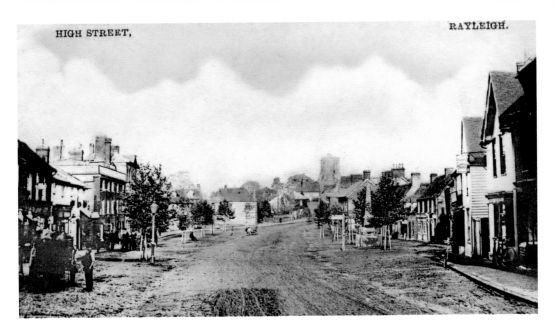

High Street from the Junction with Eastwood Road

Two postcards both looking towards our parish church from the junction with Eastwood Road but taken forty years apart.

The top earlier card gives a good indication of the state of the roads and was posted on Christmas Eve as both a Christmas and New Year's greeting card.

The bottom later card was sent just after the end of the Second World War and shows the well-known family of Britton's the Fishmongers. The town is still coming to terms with peace, although food rationing was to remain for a number of years. This card cost 2d (predecimal) to post and mentions a family day trip by steamer along the coast of France. No doubt from Southend.

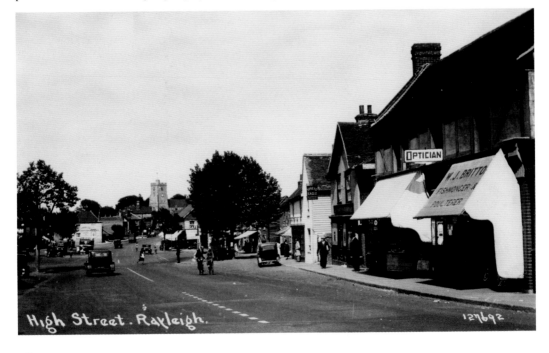

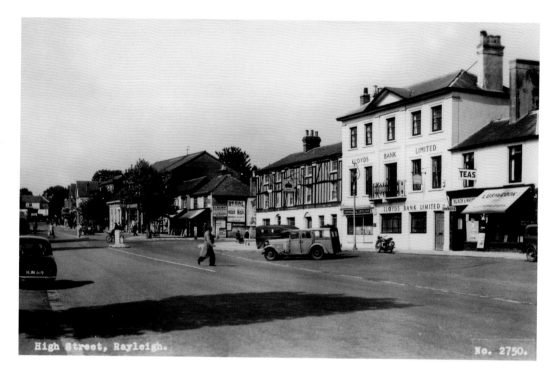

The Ever-Changing Face of the High Street

These next two cards show how Rayleigh has started to develop, and both benefit from a closer inspection. In the earlier top picture note the opticians, now part of the Lloyds Bank premises, the Black & White Café and the advert on the side panel of the building at the top of Crown Hill advertising the film *Rob Roy* at the Regal Cinema. This dates the card to post 1937, which was when the Regal Cinema opened in Bellingham Lane. In the bottom card that was posted in 1946 note the driver and conductor of the No. 7 bus having a well-earned rest before departing to Southend.

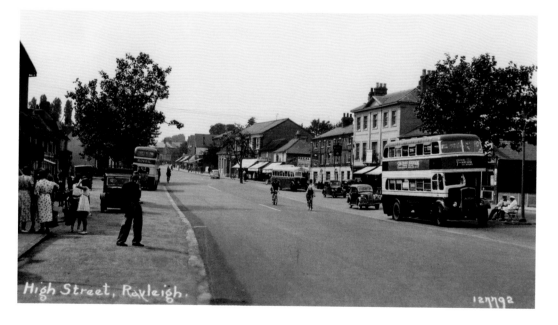

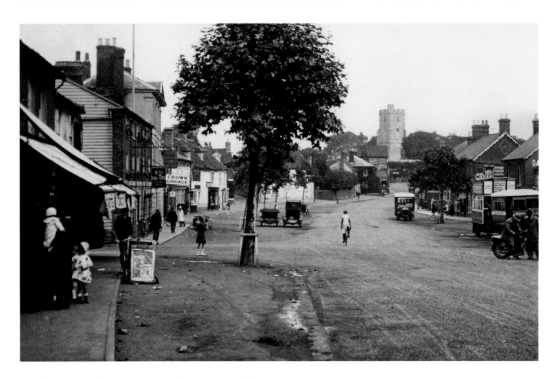

High Street at the Junction with Crown Hill

These two postcards taken from close by the junction with Crown Hill show how the High Street has evolved over the decades. In the top photograph note the tree that appears to be obscuring the sight of travellers as they turn left into Crown Hill.

By the time the bottom photograph was taken, the tree has been partly obscured by a road sign; the pavement has intruded enough for a seat for those who wish to sit and relax. More changes would follow to the appearance of the High Street at regular intervals.

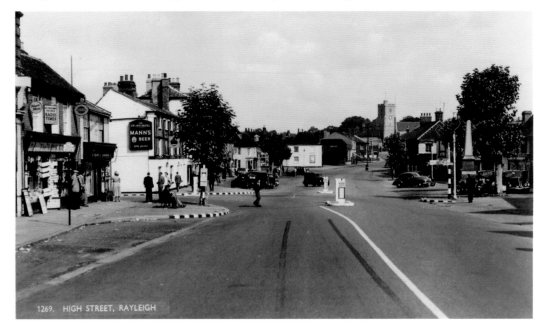

1269. HIGH STREET, RAYLEIGH

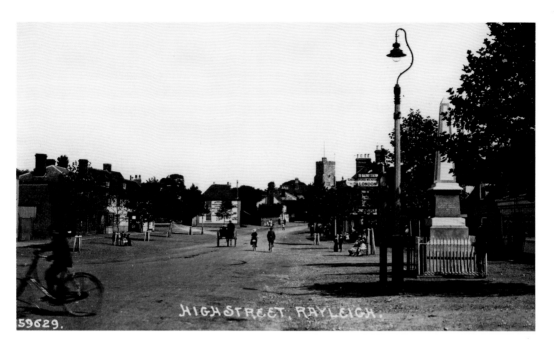

Horse Power to Motorised Vehicles

The top picture shows a scene reminiscent of everyday life in Rayleigh High Street, around 1910. Note the fingerpost showing the main road to London via Crown Hill well before the arrival of the A127 in 1925.

In the bottom picture taken close by the junction with Eastwood Road, the policeman on point duty is directing a wonderful car on its way to Southend. The trades van parked on the left outside Barnards the off-licence is from an era before yellow lines were introduced. Mr A. H. Poole one of the town's local estate agents was a proficient amateur artist some of whose drawings are held by the authors.

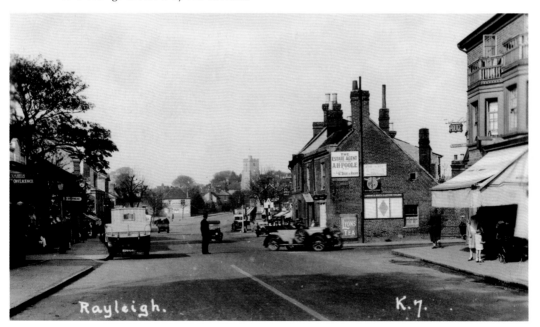

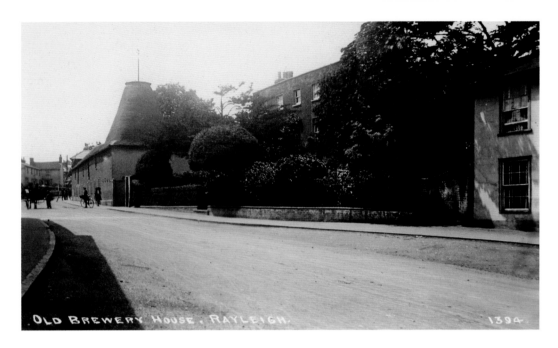

From Brewing to Tasting

The old brewery house in the top photograph shows the Old Anchor that was built in 1798. Also known as Luker's Brewery its water supply was pumped from the brickfield pond in Castle Road. The substantial early home of the Barnard family had some imitation window frames to avoid the dreaded window tax that once existed. It was later to become an off-licence, and its front window displayed carnival prizes during carnival week. The Crown Hotel was one of several local pubs in the surrounding area that stocked the local brew although at the time of this photograph, Mann's the national brewer had taken over.

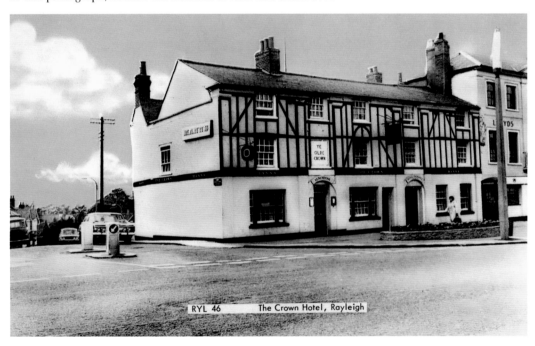

RYL 46 The Crown Hotel, Rayleigh

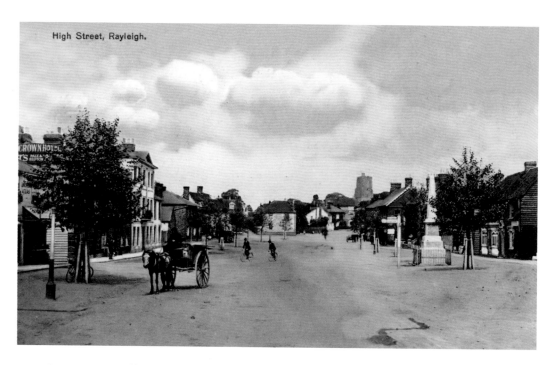

High Street, Rayleigh.

From Crown Hill Towards Holy Trinity Church

Another two photographs taken from near the same spot looking towards Holy Trinity church. Note how the mode and volume of transport has changed over time. The top picture dates after 1908 (when the Martyrs' Memorial was erected), while in the bottom picture a number of well-known Rayleigh businesses can be seen including Woods the butchers (now Costa Coffee), the estate offices of Offin & Rumsey (now Bet Fred) and Thorns hardware shop (now Savers).

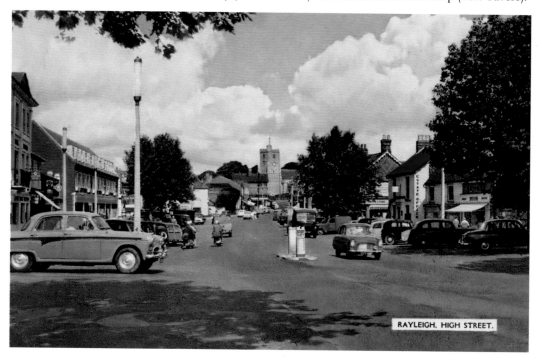

RAYLEIGH. HIGH STREET.

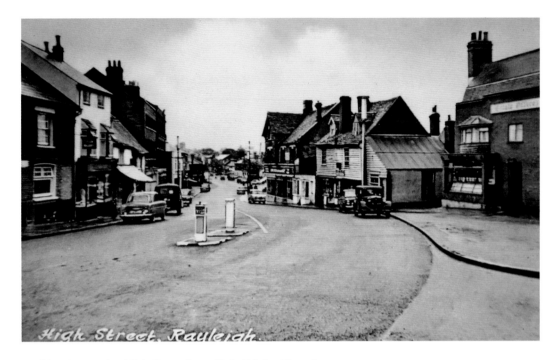

Looking Down the High Street from Holy Trinity Church

Most views of the High Street look towards the photogenic focal point of Holy Trinity church, but these two cards are looking in the other direction towards the wide expanse of our typically triangular Saxon-style High Street where the markets took place as they do today.

Note the two-way traffic system before Webster's Way and specifically how the buildings once owned by E. H. Ive (boot and shoe repairs) and Bowen and Son (confectioners) became Berry's Arcade. The Half Moon pub on the left was originally called the Greyhound.

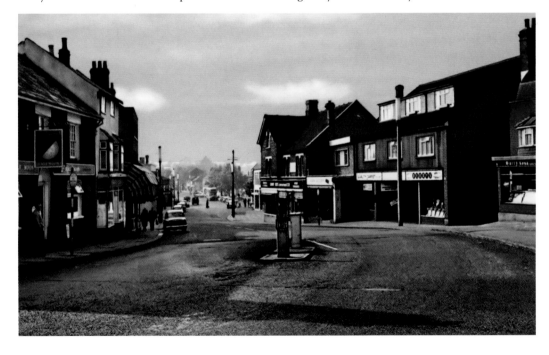

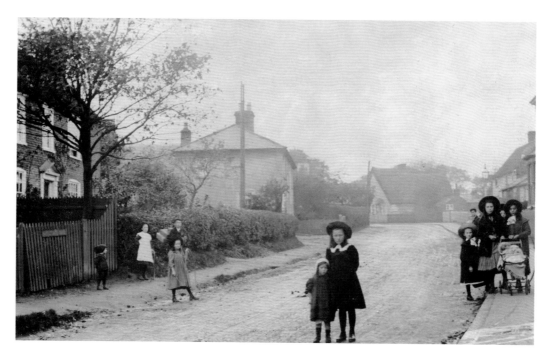

High Street from Eastwood Road Towards Castle Road

These two views taken from outside what is now the public lending library looking towards the Weir show the total transformation between old and new. Gone are the Essex weather boarded residential properties, with perhaps a small business on the ground floor. On the left once stood well-known local traders such as Cramphorns and the Waterworks Office leading up to the Elephant and Castle public house just past the junction with Castle Road.

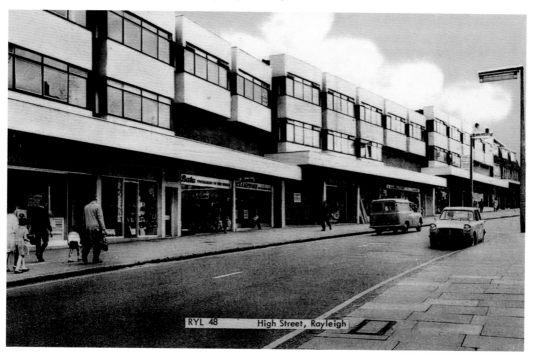

RYL 48 High Street, Rayleigh

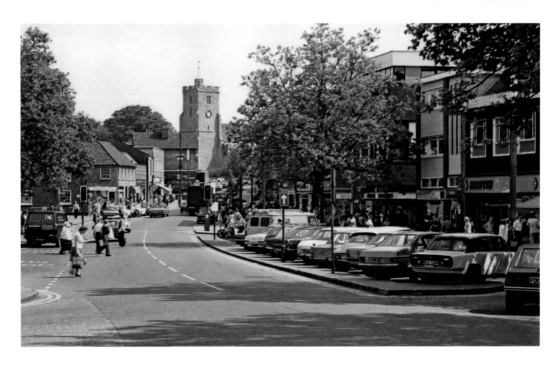

High Street from Crown Hill with One-Way Traffic

Both these cards show the ever-changing face of our High Street since the earlier days. In the top picture, taxis have replaced cars in what is known locally as the 'lagoon' (why is not known – suggestions on a postcard please). The pavement may have encroached on what was once a lovely wide expanse, and a number of the lovely old buildings have gone but enough have remained to enable a comparison to be made.

In the bottom picture note how the car parking now outside the Crown has yet to be introduced and the space for buses has also increased.

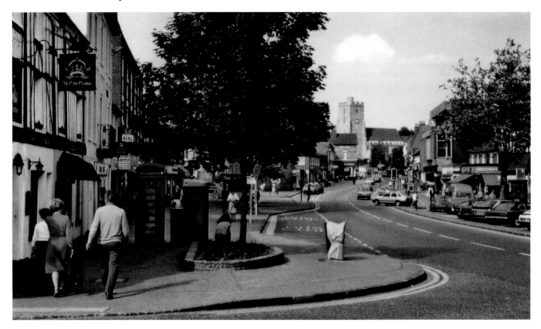

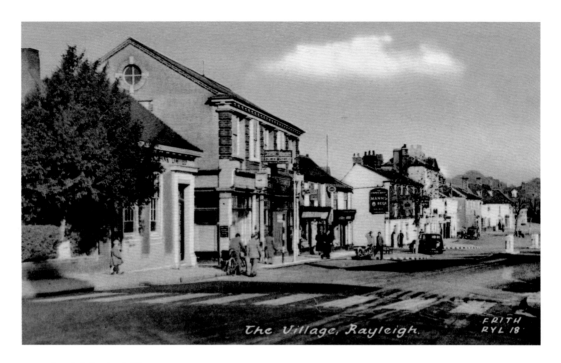

Rayleigh, the Village

Both of these cards date from the 1960s, when Rayleigh was still called a village. Notice how peaceful and tranquil the High Street looked. For many new residents moving to town from London, it was a world apart where the pace of life was totally different from what they had just left behind.

The card at the top caught the 6.45 p.m. post to London advising that mum and dad would return home the next evening. I am sure the postcard arrived before they did.

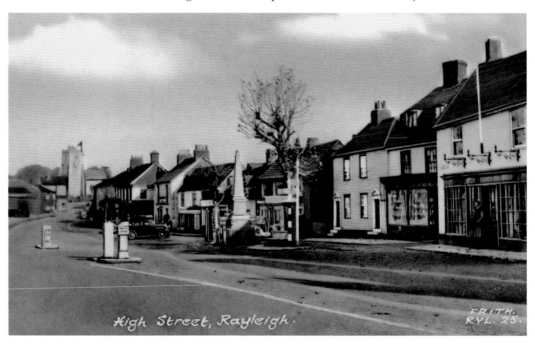

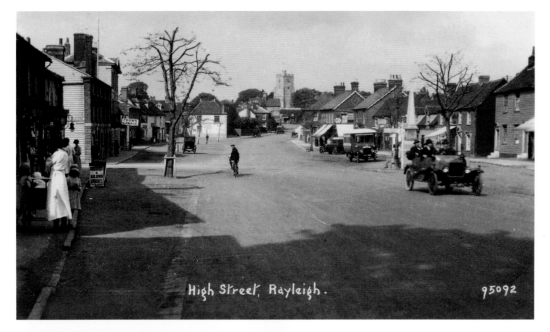

High Street, Rayleigh. 95092

High Street Old and New

These two more postcards show the ever-changing nature of the shops in the High Street. In the top photograph note the bus shortly before turning around in the wide expanse of the High Street for its return journey to Southend. Can you guess what the 'Baldwin Bombshell' was on the newspaper headline poster? Also notice the Crown Garage just past Lloyds Bank. Mr Mann the grocers at the junction with Bellingham Lane is remembered affectionately by many for the smell of fresh coffee and the tin of broken biscuits by the front door. Wonderful memories of a bygone era.

High Street, Rayleigh R.1902

SECTION 2
ROADS

London Hill, Rayleigh

London Hill, the King's Highway, the Original Road into Town

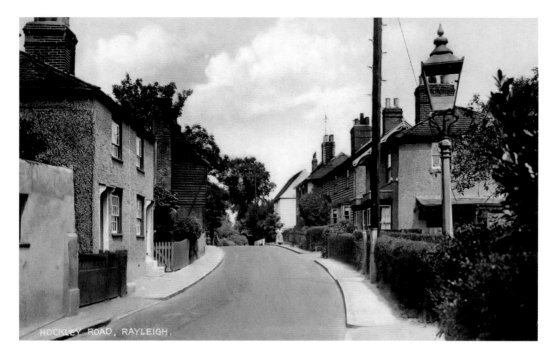

Hockley Road and Ruffles Cottage

These photographs show the Hockley Road on the outskirts of town. This was the route of the King's Highway, and seven ancient milestones on the road to Rochford can still be seen as part of our roadside heritage. In the top picture notice the last gas lamp on leaving town.

In the bottom picture, we are at the brow of the hill, and the house on the right was named Ruffles, the site of the windmill as shown on the Chapman & Andre map of 1777. At the bottom of this hill on the right once stood Laver's Farm now the site of the Fitzwimarc Secondary School that was built in 1937.

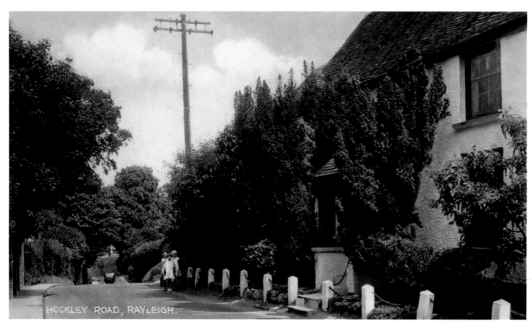

Hockley Road and Queen's Parade in Eastwood Road

Another view of the Hockley Road in this top picture with the entry on the left to the Rectory. When the old Rectory was demolished in 1967, evidence was found that the previous property had at one time a thatched roof.

In the bottom picture, Queen's Parade is in the Eastwood Road opposite its junction with Daws Heath Road. Hatton's the newsagent had been established for many years, and Longthornes the butchers has an impressive display in the window. Notice another advert for the Regal Cinema which opened in 1937 as well as the *Daily Express* banner entitled 'Hitler's Plan', both of which give a good indication of the date of this picture.

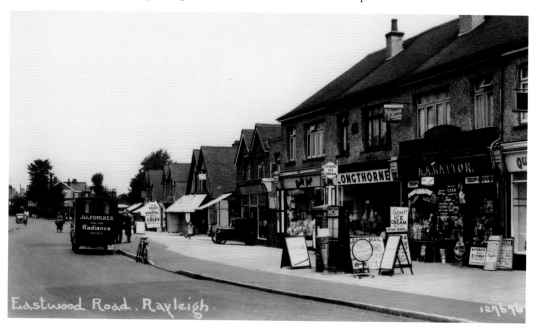

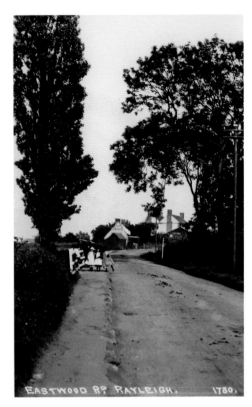

Eastwood Road, Towards Picton House
These postcards are of Eastwood Road, and both were taken close by its junction with Daws Heath Road just outside of town. The far property seen in the distance is Picton House, which was opposite to where the Methodist church is today. Close by Picton House was the Clissold Hall, one of the main entertainment venues that presented their own productions with acts including the Rayleigh Minstrels and the Brothers Tregenza. Note the cows in the pond having a refreshing drink. There were a number of other ponds around town, and cows and horses taking refreshment were a daily sight.

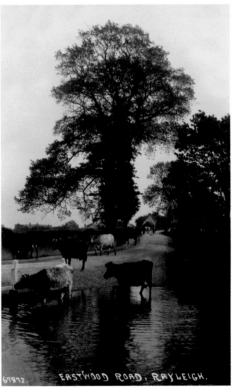

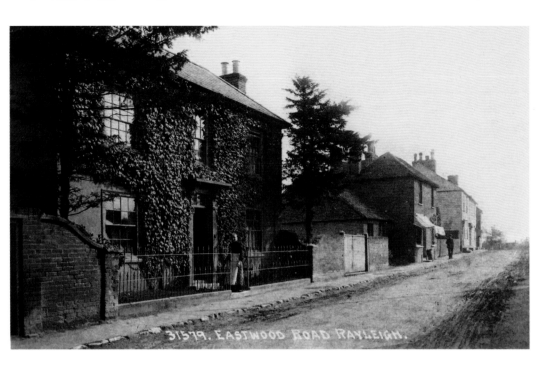

Eastwood Road, Sunnyside Cottages and the Chase

Two more postcards of Eastwood Road. The top picture is taken close by its junction at the High Street with Sunnyside Cottages on the far left in the area where Webster's Way is today. Further along the Eastwood Road, the person on the bicycle waiting to speak to the approaching lady is at the junction with the Chase. This leads to Rayleigh Lodge originally named Park Lodge by Henry VIII as the great hunting lodge of Eastwood. There is a public house on the site today.

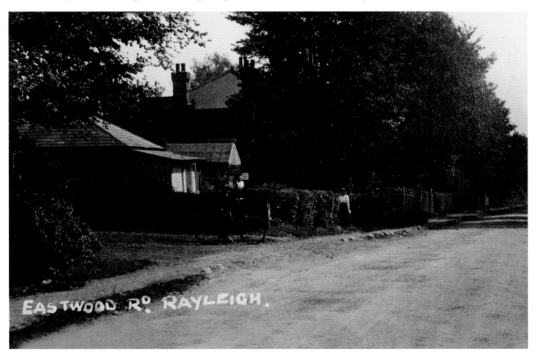

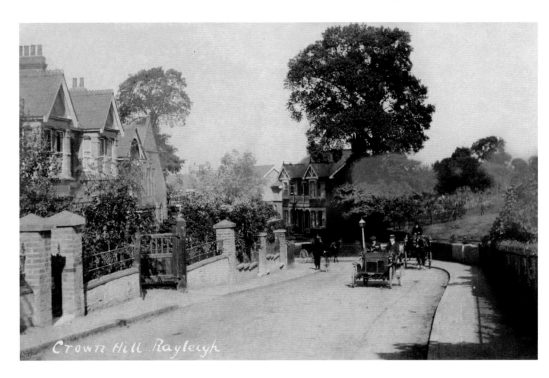

Crown Hill, Towards the Dutch Cottage

Crown Hill as shown in these postcards was originally named Crown Lane until the 1920s, which is approximately the date of this top card. Note the different forms of transport on view including a bicycle, pony and trap and a very impressive motor vehicle with a chauffeur driving his master who is in the seat behind. The Dutch Cottage is just in on the left round the corner although this road did not gain any prominence until the railway station reached town at the bottom of the hill in 1889. This hill was very dangerous in winter especially for commuters walking, or sliding, down the road on their way to the station.

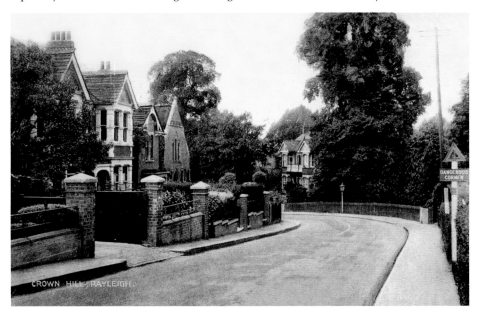

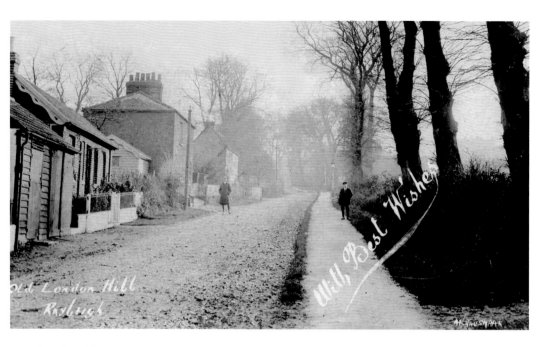

London Hill

London Hill as shown in these cards was the main road from the north and west into town. The state of this road being on a hill was sometimes so poor that in winter the stagecoach passengers had to alight to enable the carriage to reach the top. Indeed the founder of the Wesleyan movement John Wesley recorded in his 1755 diary that he had to walk up the hill at Rayleigh as the road was a quagmire. The 'peep at the windmill' in the bottom picture can no longer be seen from the road as houses now dominate both sides.

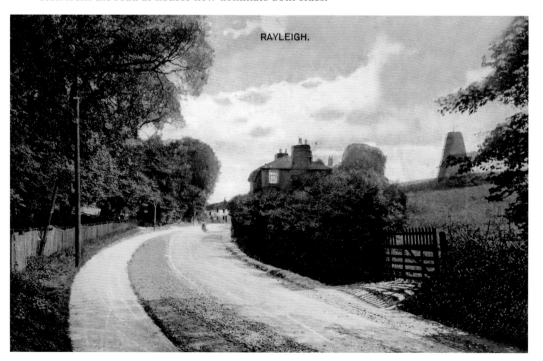

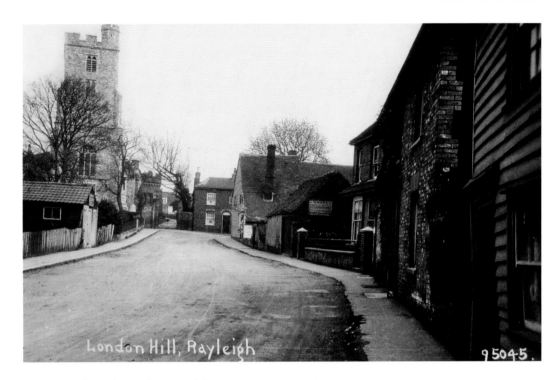

London Hill, Rayleigh

9 5045.

Top of London Hill, Viewed from Opposite Directions

These two pictures are taken from the top of London Hill but each looking in the opposite direction. The top picture towards the church shows in the distance one of the two main entrances to Holy Trinity, the other is in the Hockley Road. The Memorial Hall opened in 1926, now the site of the Royal British Legion Hall, is immediately on the left of this entrance. The road turns sharply right at the end into Church Street before opening up into the High Street. The colour photograph below shows on the immediate left the entrance to Rayleigh's tower windmill. The glimpse of the Crouch valley in the distance is evidence of why Rayleigh was an ideal site for windmills and a castle.

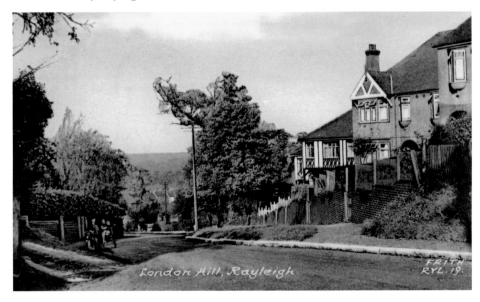

London Hill, Rayleigh

FRITH
RYL. 19.

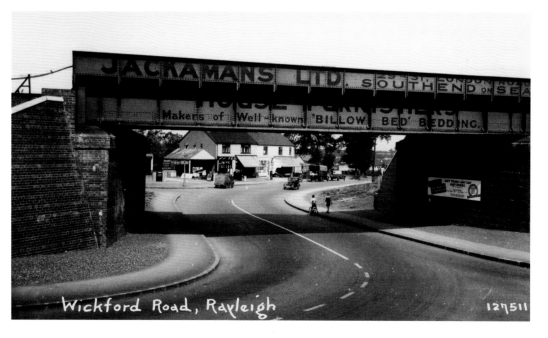

Wickford Road, Rayleigh 127511

Wickford Road and London Hill by the Railway Bridge

Now two pictures showing the bottom of London Hill in both directions. The road under the bridge was widened from a single carriageway in 1936 when the new bridge was installed. Under the bridge on the left can be seen a small parade of shops with the Travellers Joy public house on the opposite side of the road a few yards further on. This was the site of Rayleigh's prison with the gallows opposite. The area being known as Gallows Mead or Hangman's Field as a warning to travellers of the fate that would befall them if they transgressed while in town.

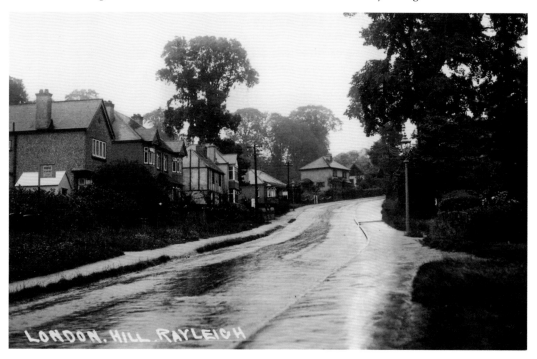

LONDON HILL RAYLEIGH

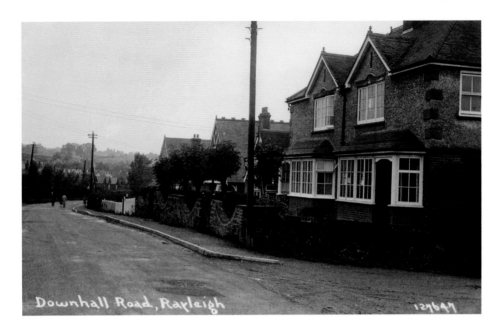

Downhall Road, Rayleigh

Downhall Road Viewed from Opposite Directions

Downhall Road was once the location for two of the significant manorial properties in the area, Downhall and Harberges. With the arrival of the railway, many new roads and estates were built, most with unmade roads still in the memory of many current residents. It was mainly the residents of Downhall Road who complained to the authorities in the early 1930s about the noise of barking dogs from the newly opened greyhound stadium along the London Road close by the site of where Sweyne Park School is today. Sufficient for the authorities to close the stadium shortly thereafter.

The five bungalows shown in the bottom picture are understood to be army surplus from the First World War.

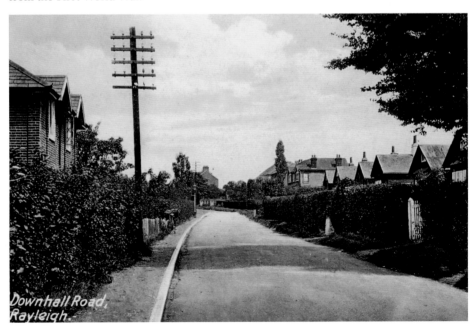

Downhall Road, Rayleigh.

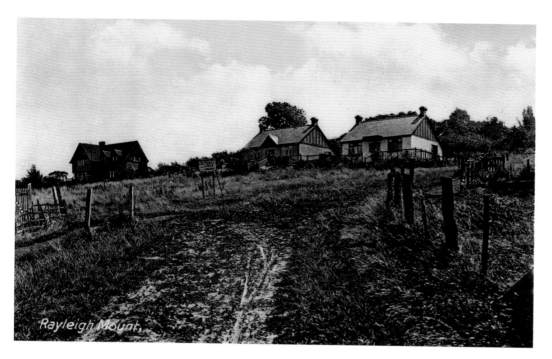

Castle Drive, Mount Avenue and Station Road

Standing outside the railway station in Station Road looking to your left, you will see Castle Drive as shown in this top picture looking towards Rayleigh Mount. It is sometimes hard to imagine why postcards were taken with these views. May be it was for a local estate agent. The road remained unmade for many years. Typical of many roads around town, indeed some still are today. The houses shown in this postcard are in Mount Avenue. In the bottom postcard, the house in Station Road is opposite the railway platform, but the views to the Mount shown here are now long gone.

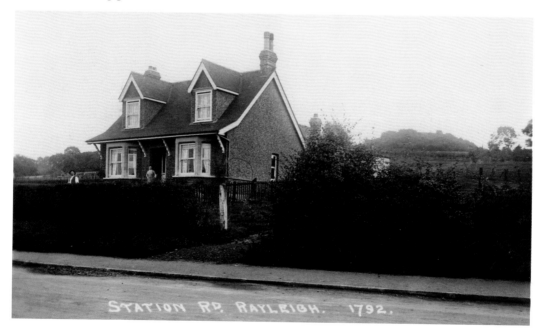

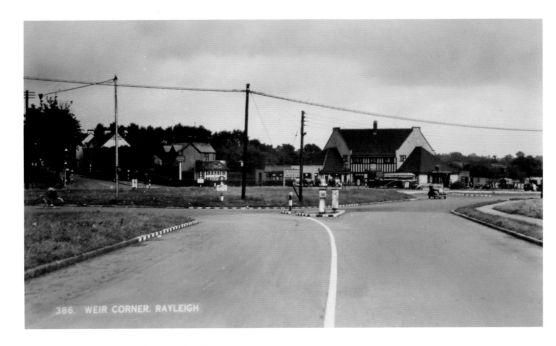

Southend Arterial Road at Rayleigh Weir

The Southend Arterial Road (A127) was the first road in this country to be built specifically for motorised vehicles. It was opened on 25 March 1925 by Prince Henry of Gloucester. One of the four official unveiling ceremonies took place at Rayleigh Weir. When the road was built, two cottages were demolished in what was originally a crossroad later to be a roundabout as shown in these two pictures. It is now an underpass. The pond shown on the left in the bottom picture with the road into Rayleigh required fences to be erected soon after the road opened as too many vehicles turning left ended up in the pond rather than staying on the road.

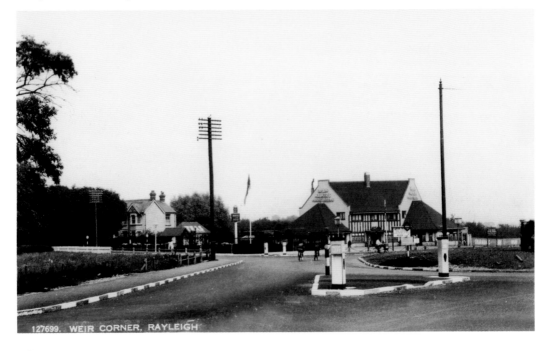

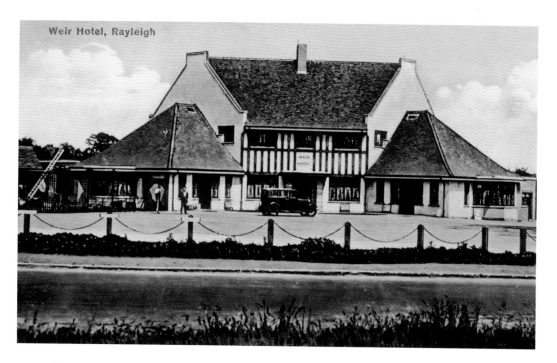

Weir Hotel, Rayleigh

The Weir Hotel and the Rayleigh Cutting

The Weir Hotel shown in this top postcard from the early 1930s opened when the licence was transferred from the Elephant & Castle pub. The Weir Hotel was a regular stop for day trippers to Southend but also for the thousands who visited the speedway stadium close by on the opposite side of the road that operated from 1948 until 1973. The bottom picture shows the Rayleigh cutting soon after the road opened just outside Rayleigh on the way to London. This part of the road was the most difficult stretch on the entire length for the workmen as all the soil was excavated by hand. Kingley Wood on the right is the site of one of the earliest manorial courts in the country.

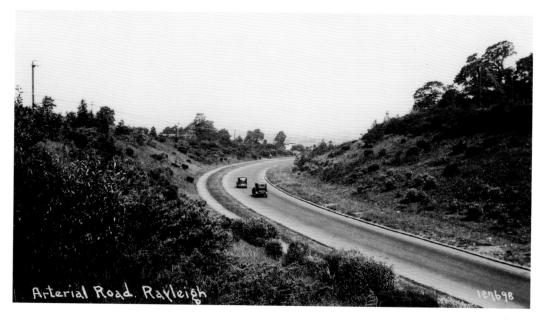

Arterial Road. Rayleigh

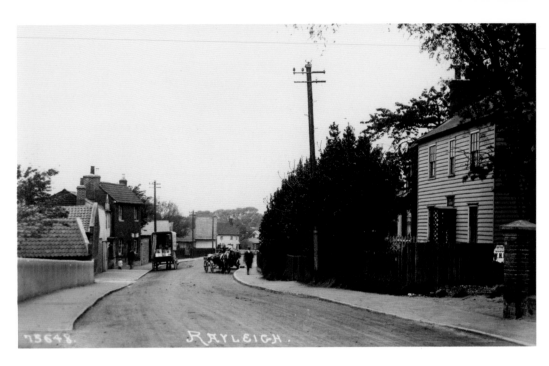

Approaching Town from Rayleigh Weir

Two views now as travellers approach the town centre from the Weir. In the top picture on the left hand side can be seen the Paul Pry public house, one of only a few in the country with such a distinctive name. Deliveries are taking place outside, and you will note the sharp right-hand bend in the road that caused problems for motorists when parishioners congregated on the pavement outside the Baptist church until the road was straightened out in the 1930s. In both pictures, you can see the outline of Sandpit Cottage mentioned elsewhere in this book.

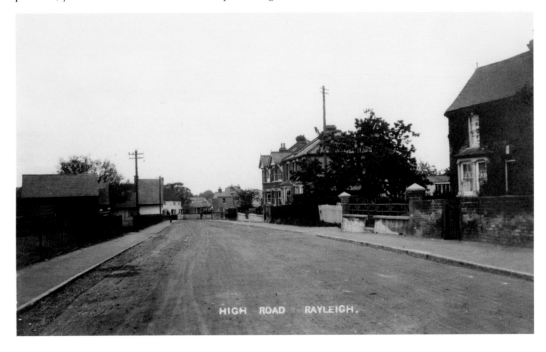

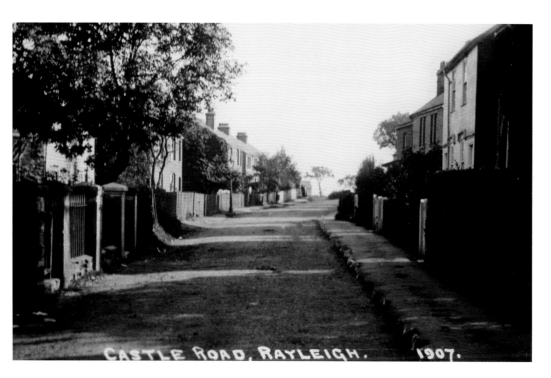

Castle Road and the High Road

Castle Road as seen in this top picture leads from the High Street to Daws Heath Road and was once named Meeting House Lane after the Revd Abraham Caley who was ejected from the parish church and held clandestine meetings in this area. The town's first permanent fire station was also located in this road, where the council refuse tip is currently located. Turning left out of Castle Road towards the Weir as seen in the second picture with Rayleigh House on the right followed by Great Wheatley Road leading to the farm of the same name, which was mentioned in the Domesday survey of 1086.

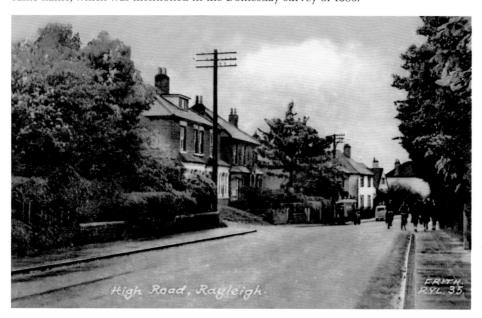

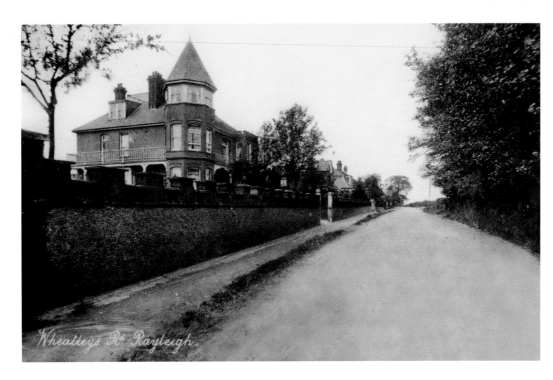

Great Wheatley Road

Great Wheatley Road is one of the most prestigious roads in town. Substantial houses can be found with private roads leading to exclusive properties. The property in this top picture is named Rosehill and was once owned by Mr Moss, a leading member of the local Peculiar People religious group. In the First World War, it was used as a billet by soldiers from the Middlesex Regiment who were training locally. This is perhaps ironical as the Peculiars were conscientious objectors. The Knoll as shown in the bottom picture is a typical example of properties in this area.

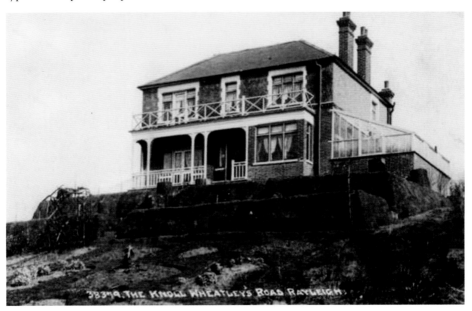

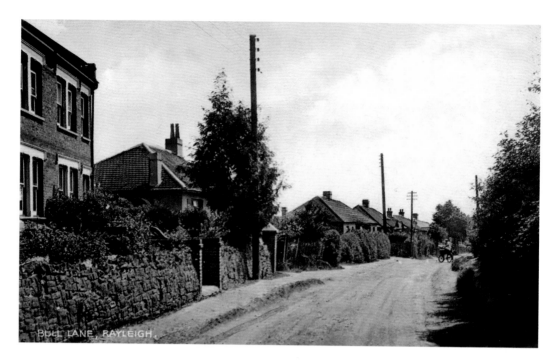

Bull Lane

Two postcards now of Bull Lane. Named after the one-way route for the bull from Webster's Meadow to the High St when bull baiting took place from 1560 for 200 years at the appropriately named Bull public house (now Kingsleigh House). Harding's the well-known sausage manufacturer until the 1980s had premises further along this road. The end of the road is the approach to Stevens and Fishers Farms. Bull Lane used to start at the High Street until the early 1970s when Webster's Way was built.

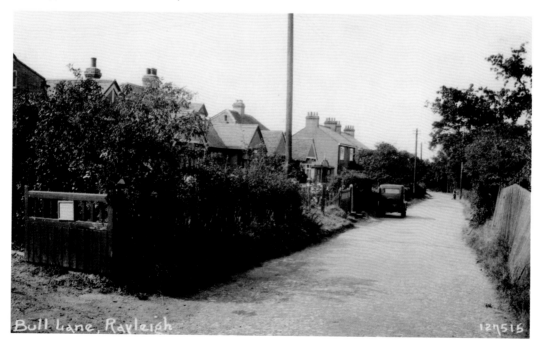

SECTION 3

HOLY TRINITY CHURCH

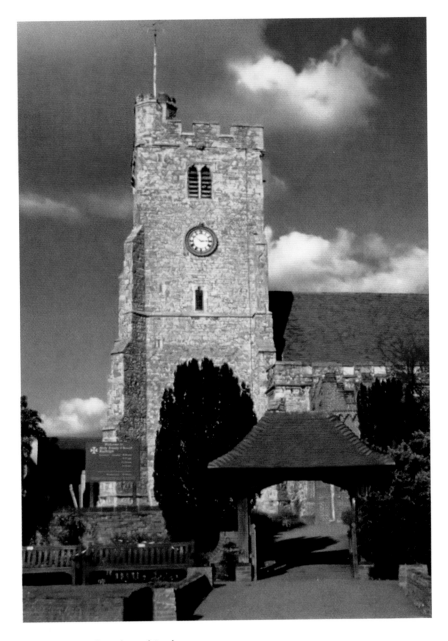

Holy Trinity Church and Lychgate

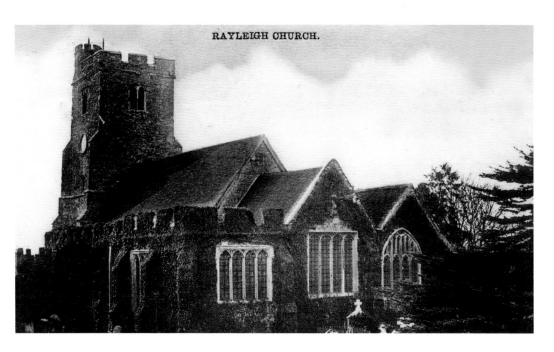

Holy Trinity Church

The top card, originally black and white and coloured at a later date, shows a lovely covering of ivy on at least two sides of the church, which by 1912 had become a serious structural problem. This top card was posted as a combined Christmas and New Year's greetings card to a family friend.

The bottom card posted in April 1927 shows that the ivy had been removed. This card was posted to a relative at the Royal Military College in Camberley, Surrey, and mentioned that the weather in March was currently ideal for gardeners.

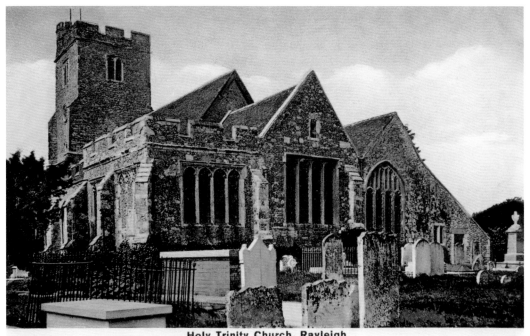

Holy Trinity Church, Rayleigh

45

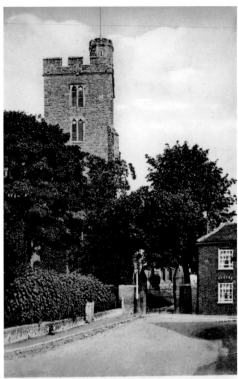

Church Tower, Rayleigh

Holy Trinity Church from the Top of London Hill

Our parish church, Holy Trinity sits at the top of our wide Saxon High Street with commanding views that can be seen for miles around. A site of religious observance for over a thousand years the present building dates mainly from the perpendicular period (fourteenth century) with many later additions. A number of interesting books and leaflets have been written on the history of the church. Well worth a read. The path leading to the entrance as seen in these two postcards was used for hundreds of years with a similar entrance in Hockley Road. Both are still regularly used today.

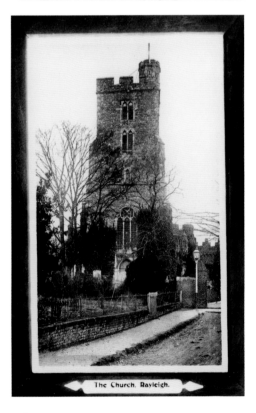

The Church, Rayleigh.

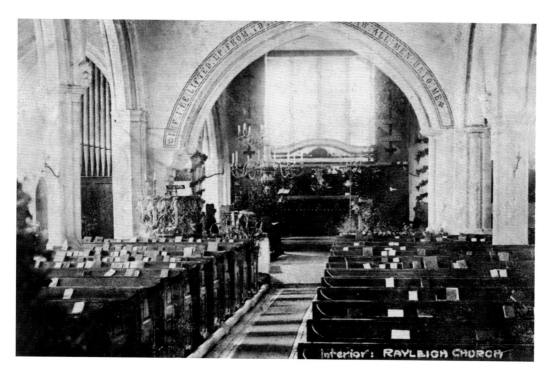

Holy Trinity Church Interior

Now two postcards showing the inside of the church although an element of 'artistic licence' has been used in depicting the stained glass windows. The top picture dates from 1906 before major restoration work in 1912, which included the removal of the ceiling. The stained glass panel in the chancel is a memorial of the First World War and thanksgiving for the restoration of peace. The mullions and stonework of the windows had to be restored and renewed before the stained glass could be put in. It was dedicated by the Bishop of Barking during a service on Palm Sunday 9 April 1922.

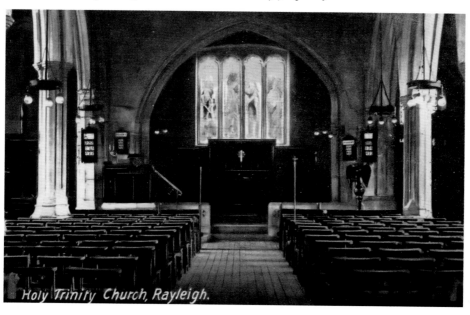

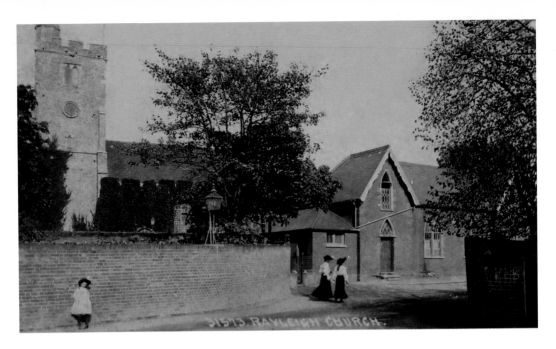

Holy Trinity Church and Parish Rooms

These two postcards are taken from a similar location but are dramatically different. The top picture shows the large wall with gas lamp on top behind, which for many years stood the schoolyard of the boy's school. The Parish Rooms on the right were built in 1863 to replace a smaller school room built seventy years before. It was used not only as a school room but also as a meeting place for a number of local clubs, groups and societies such as 'Dorcas', a ladies group who met in the 1860s and made clothes for the poor and in the 1880s the Rayleigh Dramatic Club.

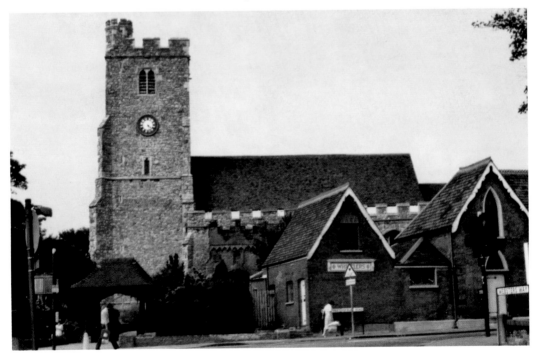

Holy Trinity Church

The two colour postcards shown here are dated shortly after 1957 when the lychgate was erected. In the top picture note how narrow Bull Lane is as it approaches its junction with Hockley Road and the High Street. Yellow lines appeared later before the road was widened.

In the bottom picture by the no entry sign is where the Christmas Tree is erected each year and is also close by the ancient 'area of correction' where once could be found the town pillory, stocks and a small lock-up which was positioned to obtain maximum exposure and embarrassment to the miscreants.

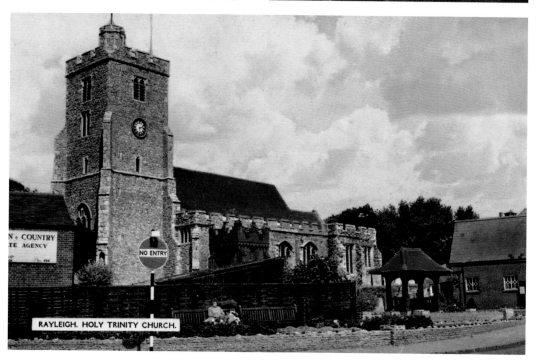

RAYLEIGH. HOLY TRINITY CHURCH.

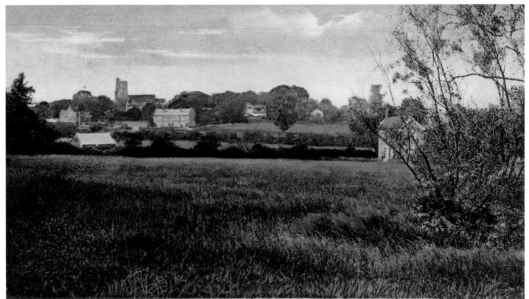

Rayleigh Church from Eastwood Road

Holy Trinity Church and Lychgate

Our parish church dominates the skyline for many miles around. This top picture was taken from Eastwood Road looking towards Bull Lane and the church. The church tower is open at least once a year and is ideal for photographers to climb to the top and enjoy the commanding views. Indeed a number of the postcards in our archives are proof of this.

The lychgate in the bottom postcard was erected by the well-known family of Dowling & Sons, builders and contractors whose shop was in Rayleigh High Street, telephone no. Rayleigh 73. A lych (Saxon word for corpse) is a covered gate traditionally made of wood and a place where the body of the deceased would be laid before the funeral.

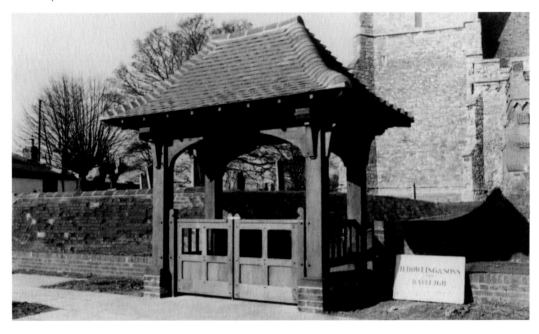

WINDMILL AND MOUNT

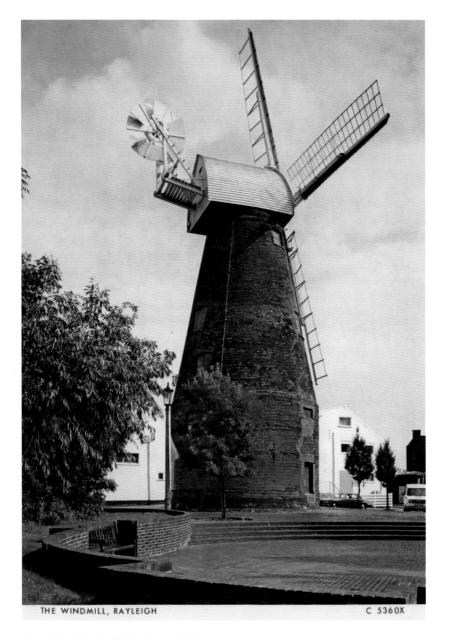

THE WINDMILL, RAYLEIGH C 5360X

Rayleigh Windmill, Built in 1809

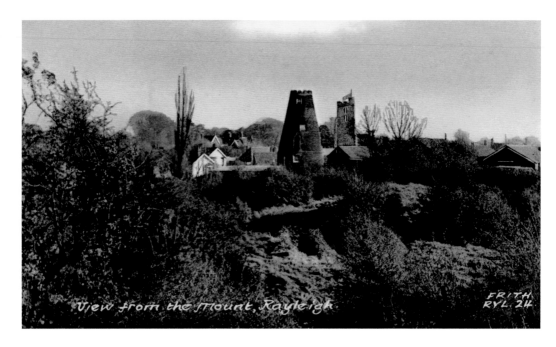

Holy Trinity Church and the Windmill from the Mount

On the western side of a range of hills, Rayleigh was a perfect location for a castle. The natural mound was raised in height, known as the motte, and a ditch added for protection. Later in around 1140, a flat area was added as the bailey. The duck pond still in evidence on the Mount today was once part of the ditch although originally it would not have retained water. Kentish ragstone was then added to the east and north slopes. Both postcards date shortly after 1910 when castellations were added as a decorative feature to the windmill that often confuses people as it is unrelated to the castle.

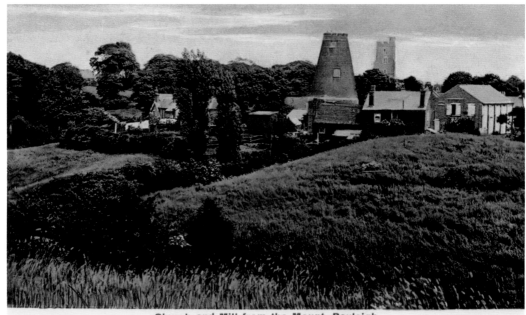

Church and Mill from the Mount, Rayleigh

The Mount from Station Road, Rayleigh

Rayleigh Mount

The castle went through a number of influential owners, and on the death of John De Burgh the estate reverted to the King who gave possession to his consort Queen Eleanor of Castile. It was she who established a royal horse stud at Rayleigh Castle. By the late fourteenth century, Hadleigh Castle was deemed more appropriately located close by the Thames, and it was in 1394 when King Richard II authorised his tenants at Rayleigh to quarry the stone from the remains of the castle, some of it used for the tower at Holy Trinity church. The site was gradually taken over by pasture for sheep and cattle and became known as Castle Hill Farm

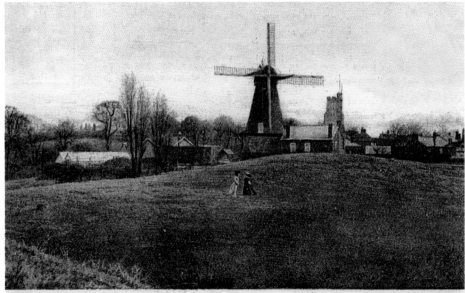

RAYLEIGH MILL u. CHURCH.

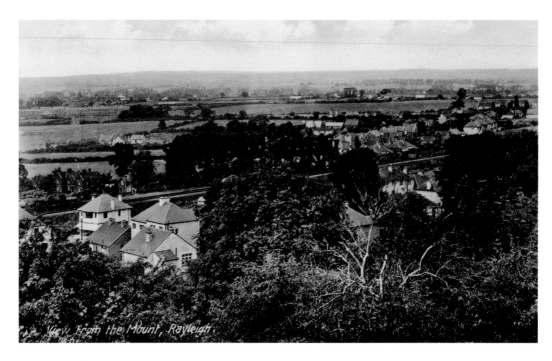

Views from the Mount

Rayleigh Castle stood on the site now known as Rayleigh Mount and was bequeathed to the National Trust in 1923 by Edward Francis a local amateur archaeologist and benefactor. It is open daily to the public. The castle was constructed in around 1070 by the Normans to suppress the existing Saxon population. William the Conqueror gave permission to Sweyne (son of Robert Fitzwimarc) to build the castle on his newly extended lands in the Rochford Hundred. Rayleigh Castle is the only Essex fortress to be mentioned in the Domesday survey of 1086.

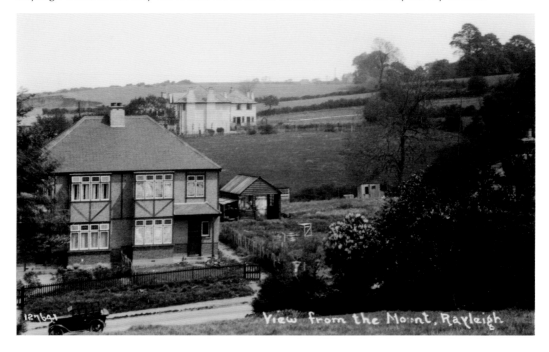

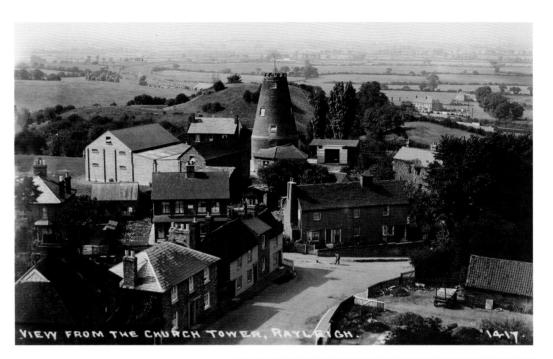

VIEW FROM THE CHURCH TOWER, RAYLEIGH. 1417.

Views of the Windmill and Mount from Holy Trinity Church These three pictures on two cards show the same view of the windmill over three different eras. Note before and after the sails, and note the clear view showing the motte and baily castle.

In 1964 the mill was purchased by the Rayleigh Urban District Council, and in 1974 the sails and cap were replaced. In 1989 the gantry was replaced. Rochford District Council undertook significant refurbishments and rebuilding works in 2004, and in 2006 the windmill reopened to the public. The ground floor is registered for civil ceremonies, while other accessible floors include a small museum, a temporary exhibition area and a National Trust display.

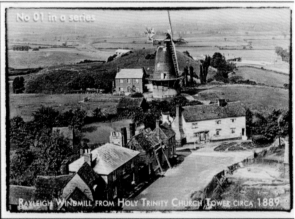

No 01 in a series

RAYLEIGH WINDMILL FROM HOLY TRINITY CHURCH TOWER CIRCA 1889

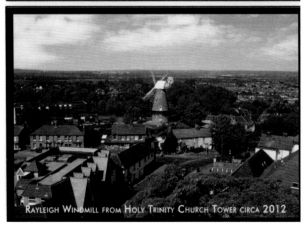

RAYLEIGH WINDMILL FROM HOLY TRINITY CHURCH TOWER CIRCA 2012

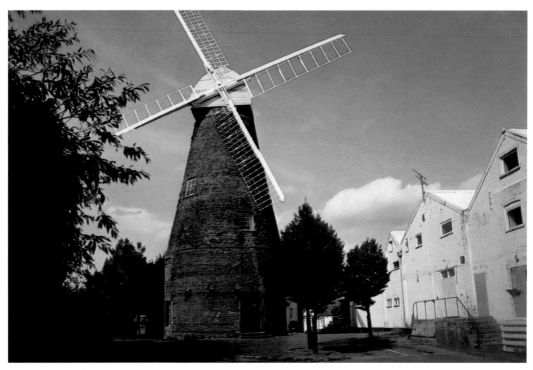

Rayleigh Windmill

Although the mill stopped working as a traditional windmill in the late 1930s, it still operated as a grain depot for many years. The grain stores can clearly be seen in this top picture close by the entrance to the windmill. Later, these buildings were used as the Rayleigh Sports & Recreational Club. Later demolished, the area now forms part of the council car park. One tragic story eagerly requested by the many children who visit the windmill today is the story of the 1943 'bath chair' murder of the owner Archie Brown by his son. You will need to visit the windmill to find out the full story.

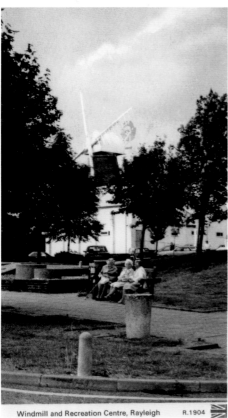

Windmill and Recreation Centre, Rayleigh R.1904

The Windmill with and Without Sails
Rayleigh windmill was built in 1809 by Thomas Higgs on land that was originally part of Castle Hill Farm. It is a brick-built tower mill, the tallest in Essex with some impressive dimensions. It is 66 feet high, the base has a 90 feet circumference, and the walls are 4 feet thick at the base with sails 44 feet long. The mill had three grinding stones. The top of the mill is called the cap that moves so that the sails always face the wind. The sails were taken down in 1906 when Mr James Crabb retired and the mill was converted to steam, then oil and then in 1937 to electricity.

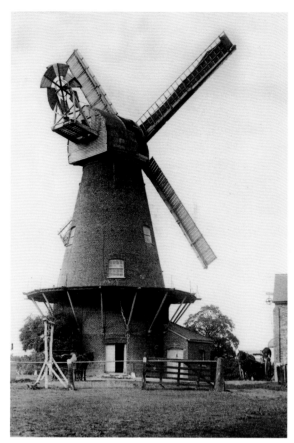

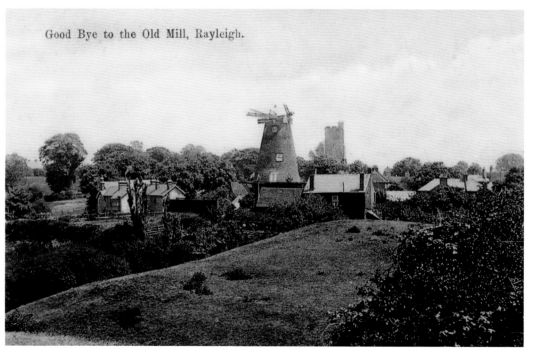

Good Bye to the Old Mill, Rayleigh.

SECTION 5
DUTCH COTTAGE

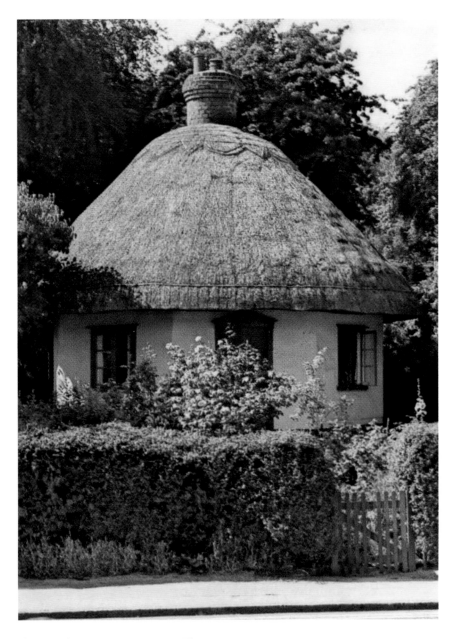

The Dutch Cottage in Crown Hill

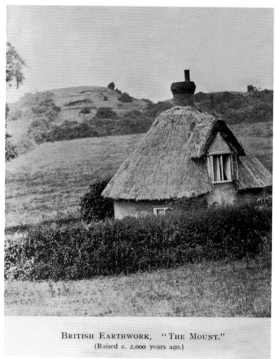

The Dutch Cottage from the Back
Two less common views showing the rear of the Dutch Cottage with its window looking out from the first-floor bedroom. For many years, it was thought that the cottage was built in 1621, the date on the lintel over the door; however, more recent scientific analysis of the materials used has established that the building in fact dates from the mid-eighteenth century.

The bottom picture shows the remains of the site of Rayleigh's motte and bailey castle on the other side of Crown Lane which was then an area for the grazing of sheep and cows.

The Dutch House, Rayleigh. 13.
(Essex)

BRITISH EARTHWORK, "THE MOUNT."
(Raised c. 2,000 years ago.)

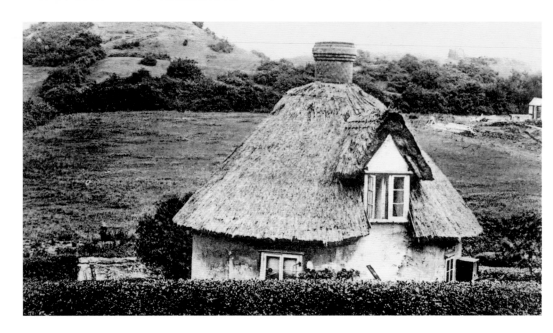

The Dutch Cottage and Crown Hill

Why the cottage was built halfway down a footpath to a farm is a mystery. It is similar to a number built by Dutch settlers on nearby Canvey Island. The footpath did not gain any significance until the railway arrived in 1889. In 1958, the cottage was sold to the Rayleigh firm J. T. Byford and Sons and in 1964 sold to the Urban District Council to be preserved as an amenity for the whole district. The bottom picture answers the question 'how many men does it take to sweep a road and deal with potholes'. You will also notice the road name affixed to the large tree in the foreground.

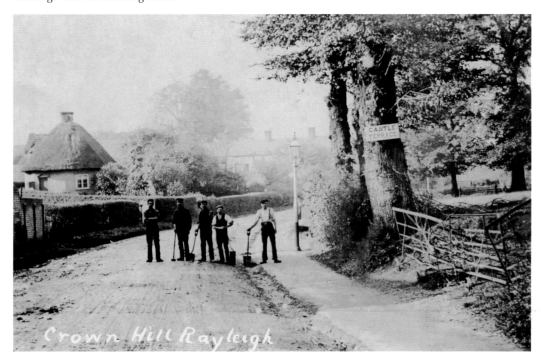

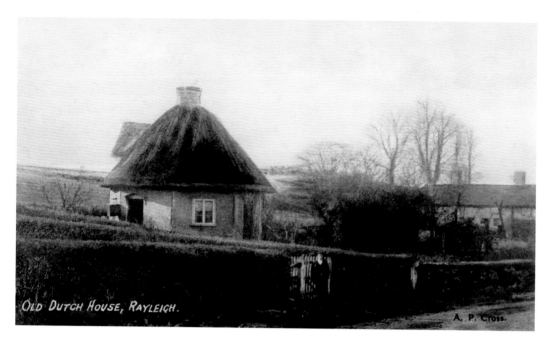

OLD DUTCH HOUSE, RAYLEIGH.

A. P. Cross.

The Dutch Cottage

The top picture shows Crown Lane looking down towards the railway station. Note the houses known as Sweeps Row where the footpath from Love Lane joined this road. These properties once housed the hounds for the local and Essex hunt which met regularly outside the Crown Hotel until 1939. Later, hunt meetings met at the Weir Hotel. Note the person standing by the gate.

The bottom picture shows a similar gate, but you will note that the vegetation has grown considerably.

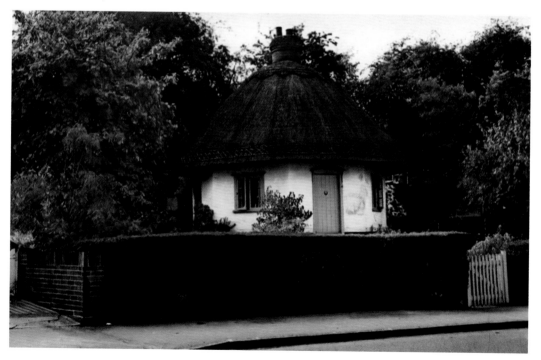

SECTION 6
MARTYRS' MEMORIAL

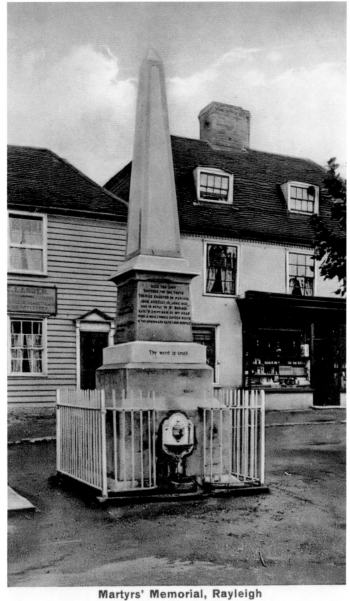

Martyrs' Memorial, Rayleigh

The Martyrs' Memorial, Erected in 1908

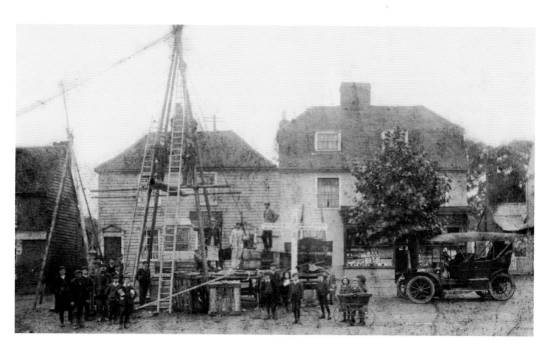

The Building and Unveiling of the Martyrs' Memorial

In 1555, two Protestant martyrs were burnt at the stake in Rayleigh High Street for their religious beliefs. The memorial was erected in 1908 by local Protestants, after an appeal, entitled 'Hallowed Ground at Rayleigh', was launched by Mr T. W. Moss of the Peculiar People religious group. Originally a plaque was considered, but within weeks the sum of £100 was raised, sufficient for the monument we see today. The top postcard shows the building work. Someone has written on the back of this card 'no the car is not mine'.

The bottom card shows the unveiling ceremony on 23 September 1908 with the whole town in attendance. The monument commemorates four Essex men who died for their religious beliefs.

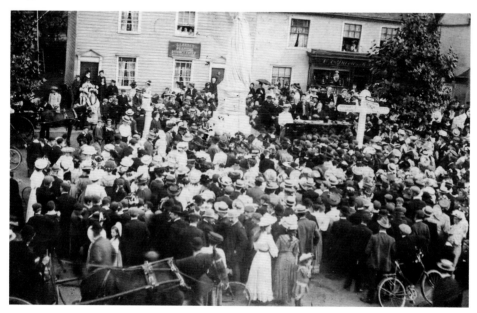

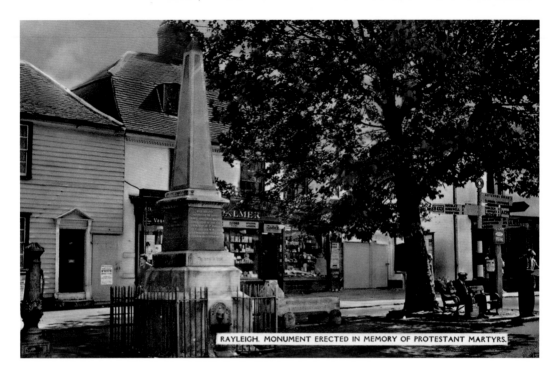

RAYLEIGH. MONUMENT ERECTED IN MEMORY OF PROTESTANT MARTYRS.

The Martyrs' Memorial

During the reign of Queen Mary (1553–58), 283 Protestants (including fifty-six women) were burnt at the stake around the country, and two (Thomas Causton an eminent resident of Thundersley on 26 March 1555 and John Ardley of Great Wigborough on 10 June 1555) were burnt in Rayleigh. When excavating the foundations in 1908, it is claimed that some remnants of the burnt stake were found, but this cannot be corroborated. The memorial also commemorates Robert Drakes of Thundersley and William Tyms of Hockley who were both burnt at one of the martyr fires at Smithfield on 14 April 1556.

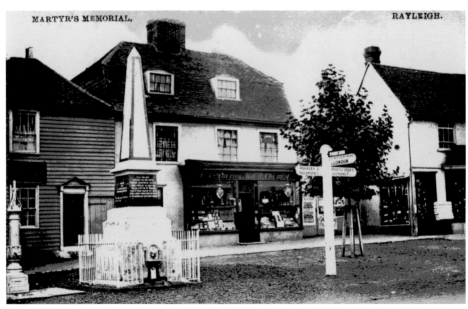

MARTYR'S MEMORIAL, RAYLEIGH.

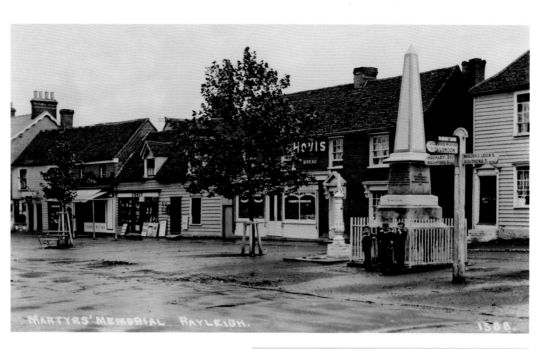

The Martyrs' Memorial and the Town Water Pump

These two pictures are from a time long gone when High Street residential properties mingled with traders such as the butcher, baker, confectioner and hairdresser as seen here. In the top postcard with the young lads standing in front of the memorial, you can see the town water pump on the left. In the 1850s, it had a sign affixed stating 'any boy found climbing this pump will be publically whipped'. What happened to any girls doing so was not recorded.

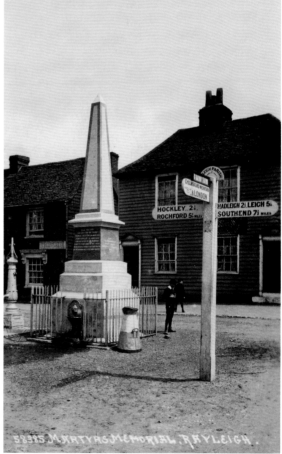

Section 7
MULTIVIEW AND MISCELLANEOUS

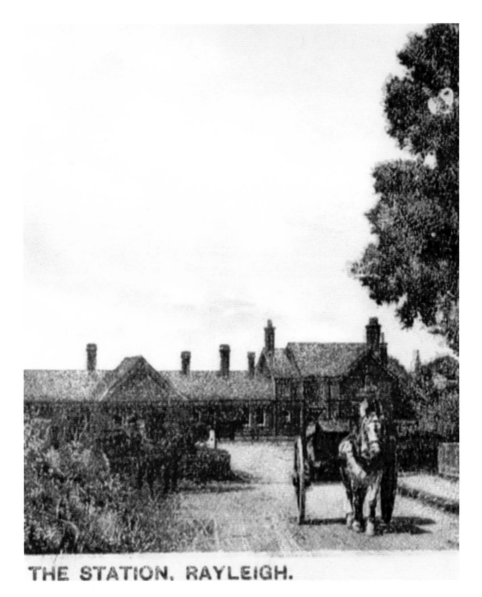

THE STATION. RAYLEIGH.

Rayleigh Railway Station, Opened in 1889

Reverend Nehemiah Curnock

These two cards are connected by the same family. The top card shows the Revd Nehemiah Curnock, the Rayleigh Methodist minister who in 1908 deciphered the diary of John Wesley which had lain undeciphered for over a hundred years. The achievement was of international significance, and the story appeared on the front page of the *New York Times*.

The bottom picture shows the aftermath of a brick thrown through the window of the Post Office (now Specsavers) in Rayleigh as part of the suffragette protest movement. Although an accomplice was arrested leaving the scene, the instigator was none other than the Revd Curnock's daughter.

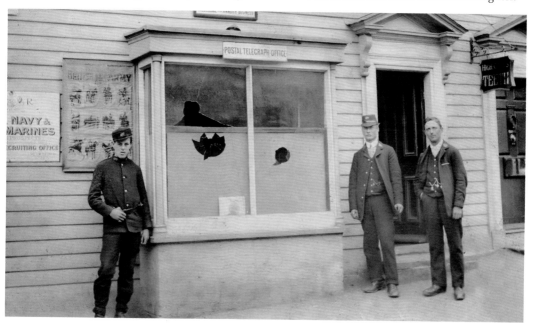

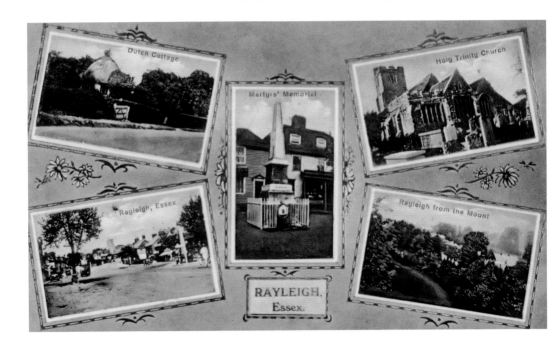

Multiview and the First World War

The multiview card was very popular as you could use four or five pictures on the same card. They include photographs that could be purchased individually or in a group and would give a good range of alternative views of the town. The bottom picture tells its own story. In April 1915, the 16th battalion (the church lads' brigade) of the King's Royal Rifles were billeted in town for eight weeks as part of their training before embarking to France in January 1916 to take part in the first battle of the Somme, many never to return. Cards were sent to family members as a way of keeping in touch.

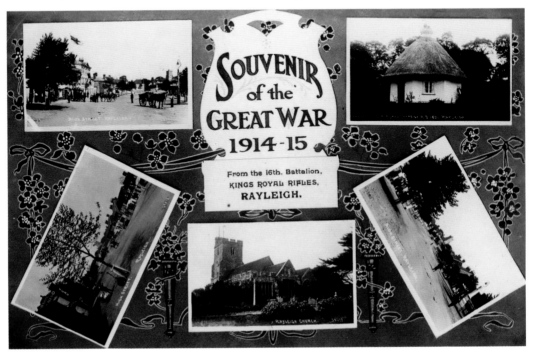

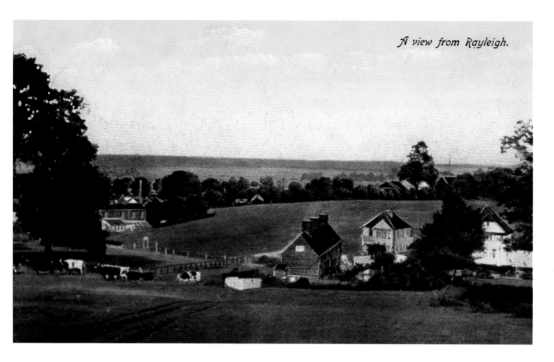

A view from Rayleigh.

Views Across Country

These cards depict how Rayleigh was between the two world wars. Both date from the early 1930s. The rolling countryside, cattle in the fields and peace and tranquillity is all around. The town's population is gradually increasing as more commuters move out of London and the suburbs. Many of the local roads are still unmade, everyone knew everyone else, and strangers were a rarity. Car and coach travellers would travel through town sometimes stopping for refreshments, but they were soon on their way and life returned to normal. By the end of the decade, all this was to change.

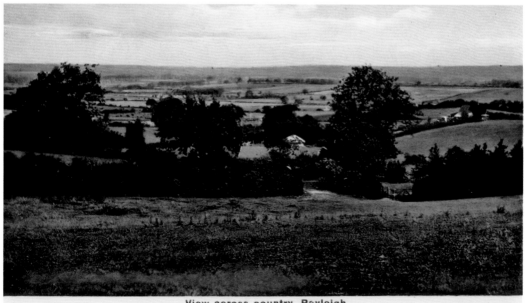

View across country, Rayleigh

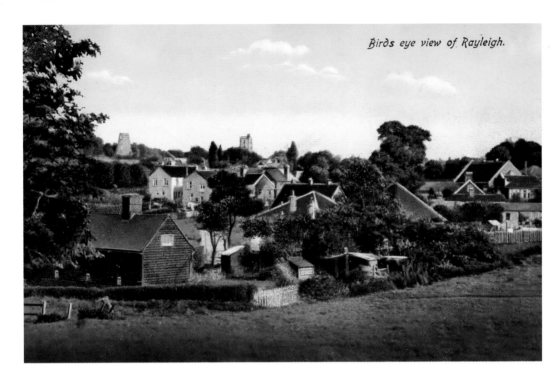

Birds eye view of Rayleigh.

Views of Rayleigh

The top picture gives a bird's eye view of Rayleigh with its two distinctive landmarks Holy Trinity church and the windmill bereft of its sails. Most of the open space and trees in this picture have now been replaced with roads and houses. The large pond in the bottom photograph with its farmhouse peeking behind the trees may appear to be unfamiliar to many local residents. The pond may have gone, but the house at the junction of the A127 and the High Road into Rayleigh is still with us today as the farm house of Weir Farm.

By the roadside, *Rayleigh.*

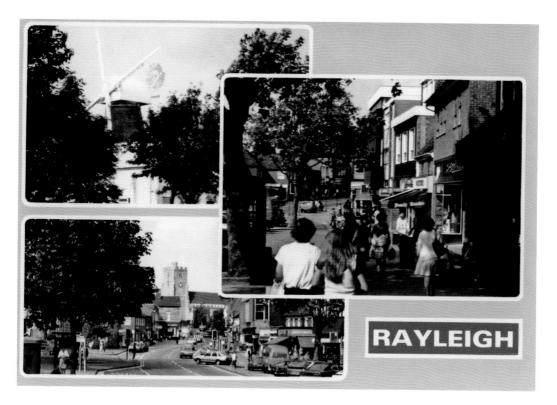

Multiview Cards

More familiar local scenes instantly recognisable. By the 1980s, the trend for collecting cards and placing them in your own album and not posting them became the norm. While lovely to have a photographic record of an era, the loss of social interchange between families and friends by this method is a shame. Now of course replaced by instant technology.

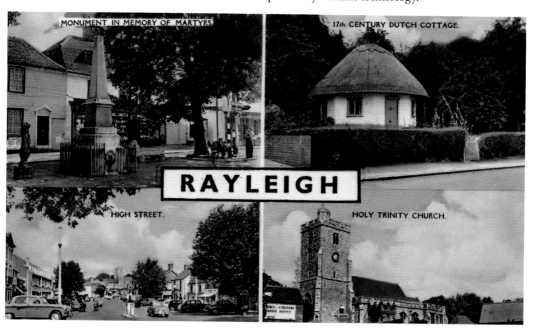

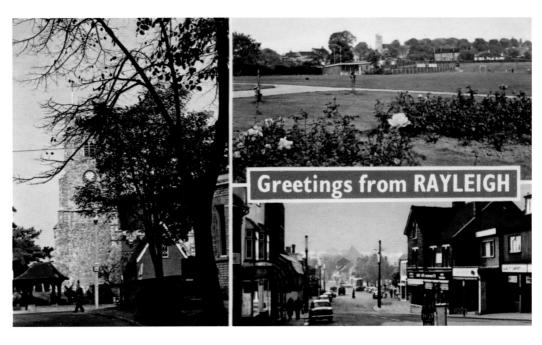

Multiview Cards

More versions of the multicard. The top picture dates from the 1960s. A familiar story on the back of a young lad on holiday with a friend writing home to his parents. The detailed description on the reverse indicates that he has visited many different towns in Essex. The bottom picture from the 1990s shows scenes familiar to us today. Even so some of the buildings have been demolished, businesses changed hands and the Dutch Cottage rethatched.

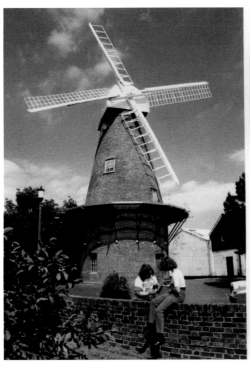

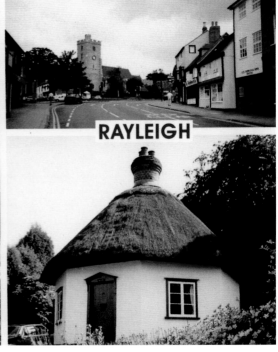

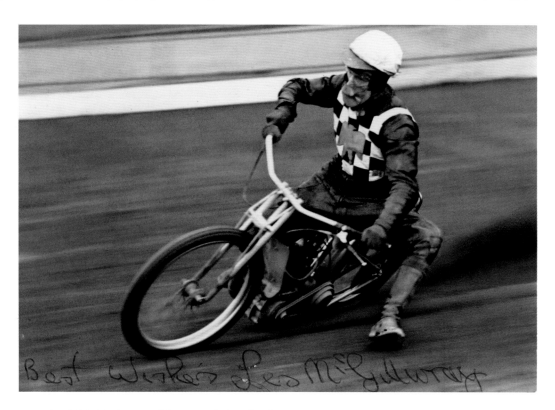

Rayleigh Rockets and Sweyne Park School

This top postcard is a promotional one issued by the Rayleigh Rockets speedway team and is signed by the well-known rider Les McGillvray. Obviously a collector's item for a fan and far too precious to send. Far better to add to the album. The Rockets stadium was close by Rayleigh Weir, and speedway meetings were held (as were greyhounds/stock cars and much more) from 1948 to 1973 and fondly remembered by all those who attended. The bottom card dates from 2009 and was sent as thank-you note by Sweyne Park School for a presentation we gave on local history. Far better to receive than an email.

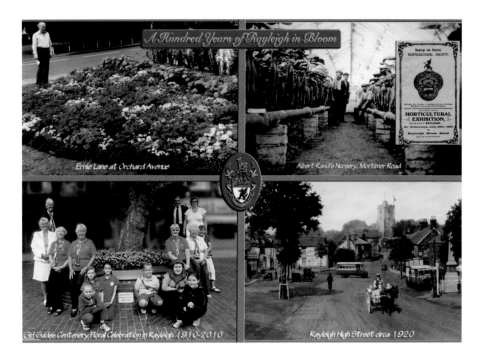

A Hundred Years of Rayleigh in Bloom

Ernie Lane at Orchard Avenue

Albert Rand's Nursery, Mortimer Road

Girl Guides Centenary Floral Celebration in Rayleigh 1910-2010

Rayleigh High Street circa 1920

Modern Multiviews

Postcards are a time capsule not only of the past but also of the present as seen in these next two examples. Why tell one story when you can tell four all at the same time. The top photograph shows a hundred years of 'Rayleigh in Bloom', eminent Rayleigh historian Ernie Lane admiring the floral display he maintained at the junction of Orchard Avenue and the High Road for twenty-five years and the Girl Guides and Horticultural Society with anniversary celebrations. Three of Rayleigh's distinctive landmarks on the bottom card showing the church, Dutch Cottage and Martyrs' Memorial.

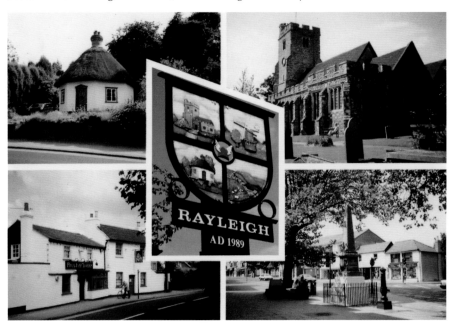

Rayleigh in Bloom, 2010
These two modern cards were issued by Rayleigh Town Council as part of their annual 'Rayleigh in Bloom' project that involves the local community and schools as a key aspect. It is far more than just a few flowers in position in the High Street. The top card was designed by Key Stage 1 pupils at Rayleigh Primary School, while the bottom picture was designed by Key Stage 2 pupils at Glebe Primary School, and shows distinctive local landmarks on a cloth patch.

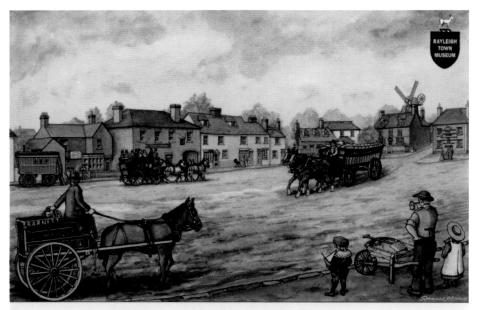

Scenes of Olde Rayleigh No.1

Rayleigh Town Museum Postcards

It is much more difficult to purchase modern postcards today when visiting anything other than major tourist attractions. Once again Rayleigh leads the way with these series of scenes depicting 'Olde Rayleigh'. Full historical details are given on the back still with enough room for a message, stamp and address. The original paintings of these cards by local artist Spencer Welsh will be on display in the town museum, and it is intended to continue to produce modern-day postcards. Examples can be found elsewhere in this book.

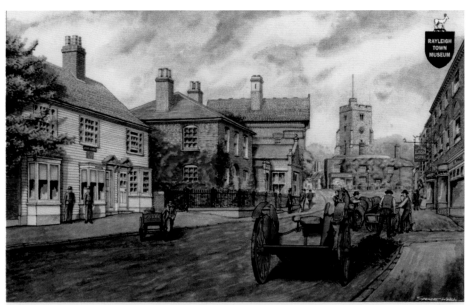

Scenes of Olde Rayleigh No.3

SECTION 8
CARNIVALS

Carnival Float in High Street in 1950s, Devenish & Son Lorry

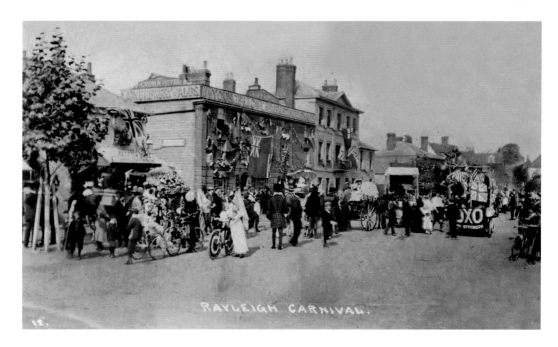

Rayleigh Carnival and Decorated Bicycles

The Crown Hotel and Lloyds Bank have been decorated for the occasion, and it appears that the football team on the float had Oxo for added strength. Note how narrow Crown Lane is by the side of the Crown with Martin Tweed's Tea Rooms on the opposite corner.

In the bottom picture, we see Gilson's the grocers (now Dorothy Perkins/Burtons) with a shop named The Library next door. A number of ladies on bicycles in costume are evident. This postcard appears to be No. 43 in a series, and although we have one or two in our collection, there are a number still to collect.

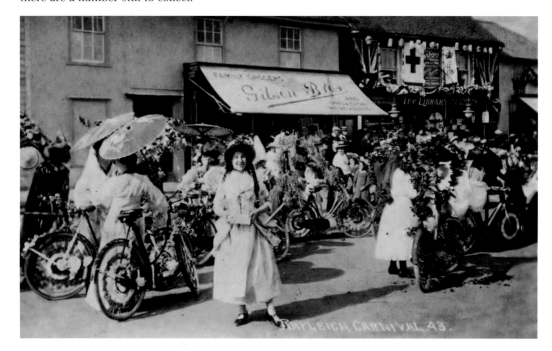

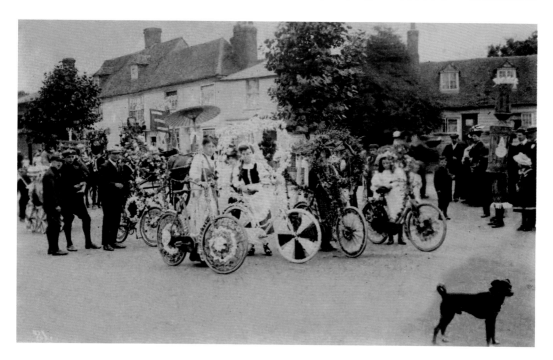

Rayleigh Carnival

The carnival procession paraded along the High Street with members of the public, including their dogs, watching from either side. The top picture from 1908 clearly evidences the whole community taking part with some proud family members admiring the bicycles on display. The property that can be seen on the far left with the archway is the Chequers Pub.

In the bottom picture looking towards the church on the right hand side is the house of Mr Webster the butcher with his shop next door. The horse and carriage have apparently stopped for a rest as has the dog underneath appearing to be sheltering from the sun.

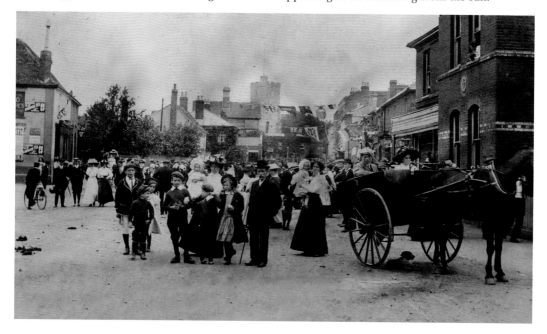

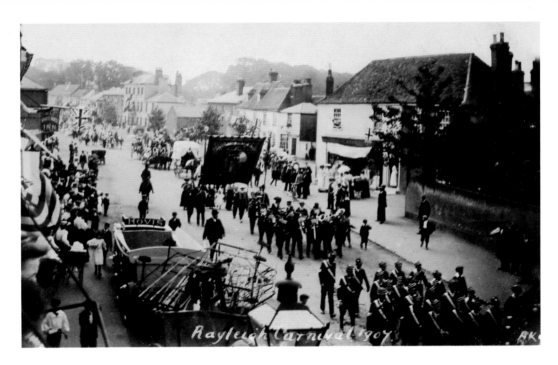

The Carnival Procession

In the top photograph, the marching band passes the White Horse Inn as our view takes us towards Lloyds Bank. The procession heads towards the church with marshals in evidence for crowd control. Note the advert for Hovis bread in the foreground.

Do you have any idea where this next picture is of the 1908 carnival? The large distinctive three-storey property on the left is Dollmartons (still with us today) and the two properties on the left immediately behind the row of spectators were demolished when Eastwood Road was later widened. The fence with trees behind on the right is sheltering Barnards now the site of Superdrug.

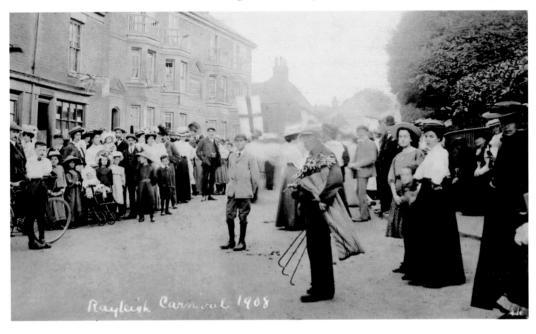

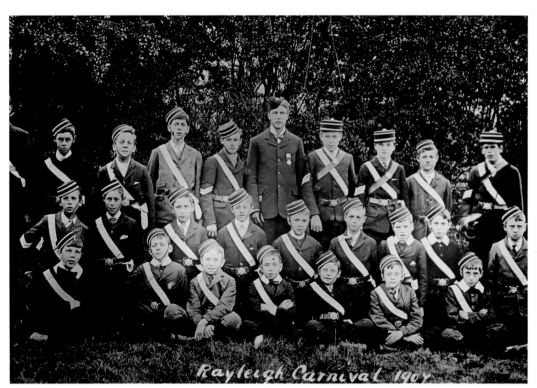

Rayleigh Carnival

The top picture is of the Boys' Brigade in 1907, some of whom would later serve their country in the First World War. Most local clubs and groups would assist the carnival either in the procession or by helping behind the scenes. Bicycles were a common theme in many carnivals, which despite the sometimes unreliable roads were often better than walking many miles. Indeed they were also more affordable than other options. But where was this photograph taken? The shop has no name, a building on the other side of the road can be seen reflected in the window but not sufficient to confirm its precise location.

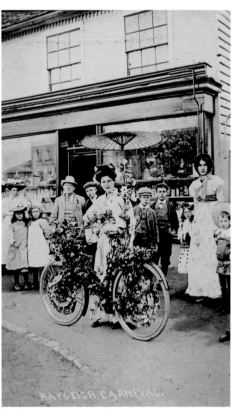

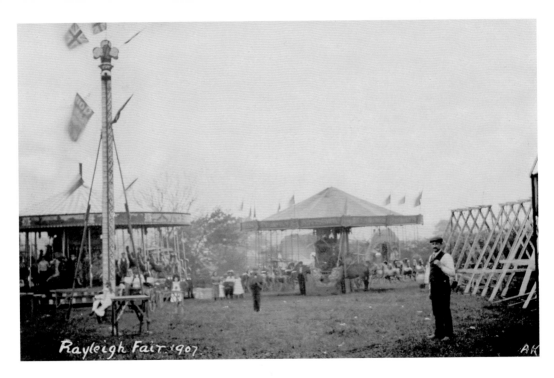

Rayleigh Fair 1907

The Carnival Funfair and the Carnival Prizes

The top card shows the fun fair in Webster's Meadow and is from the 1907 carnival. It was posted to a young lady in the Channel Islands as part of a regular exchange of cards between two young girls. Most of the people in this photograph appear to be standing still, so this may well have been a posed photograph. Each year one major source of income was from the carnival prizes, and in this bottom card you can see the selection of prizes on display in Webster's Meadow.

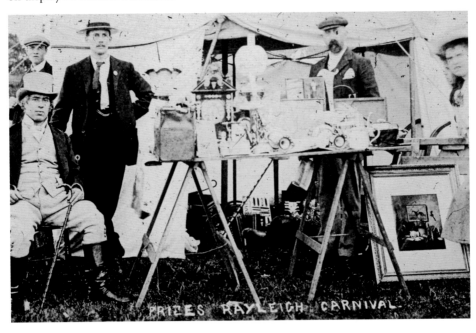

PRIZES RAYLEIGH CARNIVAL

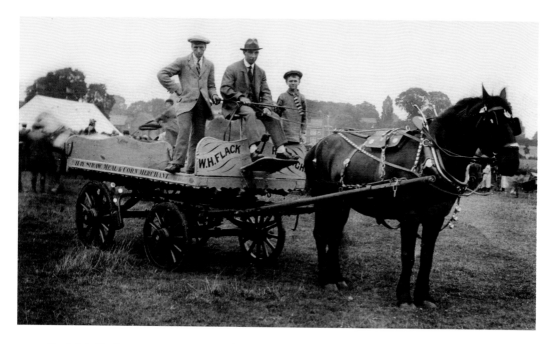

Rayleigh Businesses in the Carnival

There is long tradition of carnivals in Rayleigh with many local families taking part. Most local businesses would assist by giving freely of their time and service. The top photograph shows members of the well-known Flack family who owned White House Farm (telephone Rayleigh No. 2), and the glimpse at the houses in the background of Bull Lane confirms the location as Webster's Meadow (now King George's Playing Field).

The bottom photograph is of the carnival float for the Ancient Order of Foresters. Note on the driver's door the distinctive name of F. Boosey & Sons, coal merchants. Once again the view of Holy Trinity in the background confirms the location.

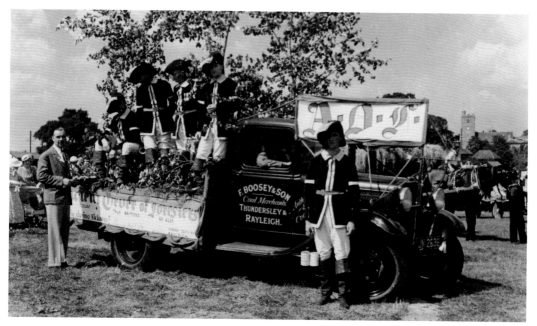

SECTION 9

ADVERTS

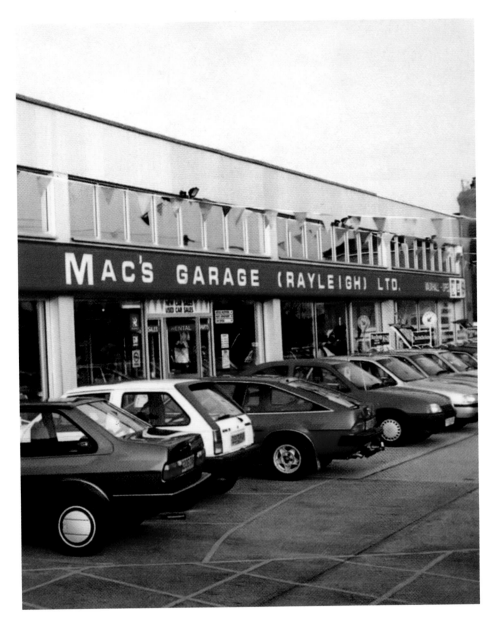

Mac's Garage, Eastwood Road

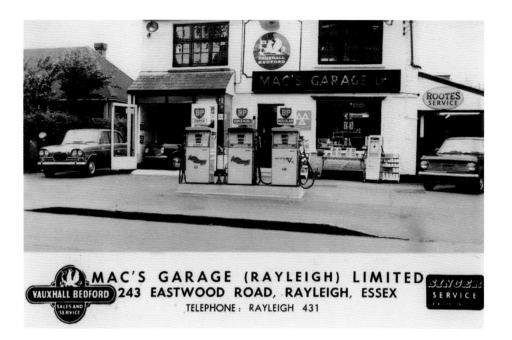

MAC'S GARAGE (RAYLEIGH) LIMITED
VAUXHALL BEDFORD 243 EASTWOOD ROAD, RAYLEIGH, ESSEX
SALES AND SERVICE
TELEPHONE: RAYLEIGH 431
SINGER SERVICE

Mac's Garage Old and New

We contrast the old and new with these two postcards of Mac's Garage located in the Eastwood Road close by the Chase. Tragically there was a fatal aeroplane accident when a newspaper plane crashed into the side of the garage on 12 September 1987 killing the pilot Hugh Brown. Miraculously no one else was injured, and eyewitnesses felt that the pilot deliberately avoided the adjacent houses when crashing early in the morning to avoid further loss of life. A heritage plaque commemorates this tragedy. Mac's Garage has now closed, but a Sainsbury's Local occupies part of the site.

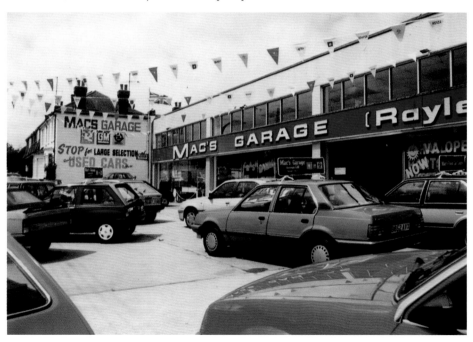

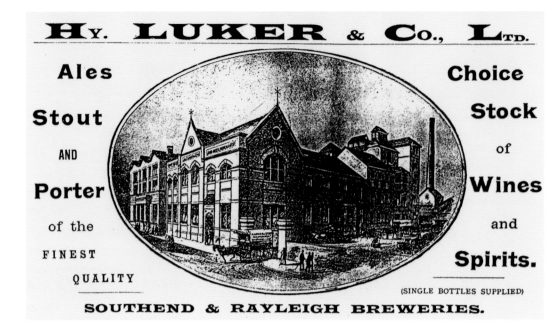

Hy. LUKER & Co., Ltd.

Ales
Stout
AND
Porter
of the
FINEST
QUALITY

Choice
Stock
of
Wines
and
Spirits.

(SINGLE BOTTLES SUPPLIED)

SOUTHEND & RAYLEIGH BREWERIES.

Luker's Brewery and the Paul Pry

Postcards advertising local businesses were once common before emails, text messages and the Internet. Luker's the Brewery featured elsewhere in this book had their main premises in Southend High Street near Central Station. Long since demolished but still remembered by a road in Southend named Luker Road. Public houses often produced cards as an advert for both existing and potential customers, and this bottom card shows an internal view of the Paul Pry public house in Rayleigh High Street. The telephone number gives a clue to its date.

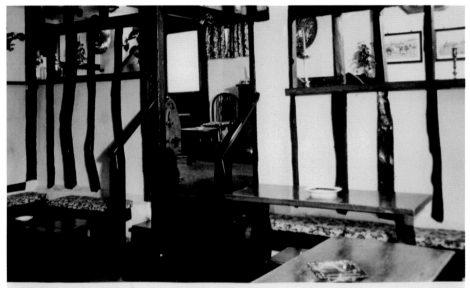

The Paul Pry . High Road . Rayleigh . Essex
Telephone: Rayleigh 2859

86

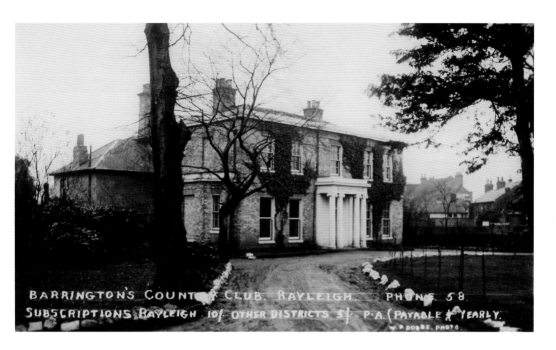

Barrington's Country Club and the Bellingham House Restaurant

Barrington's Country Club shown in the top picture was a very exclusive club for gentlemen only. It opened at 11 a.m. on Saturday 15 December 1928 but closed shortly thereafter. It reopened on Saturday 30 November 1929, but this time the ladies were admitted. The Bellingham Restaurant and guest house at the junction of Bellingham Lane feature in the bottom picture. The road was originally named Back Lane prior to Mr Bellingham purchasing the property. The building was over time a private house, a private girl's school, an antique shop, a cafe and a restaurant. The school gymnasium which was alongside Bellingham Lane was the site of Rayleigh's first permanent cinema.

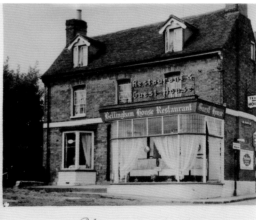

MORNING COFFEES
LUNCHEONS
AFTERNOON TEAS

We shall be pleased to quote for parties and outside catering without obligation. Menus on request.

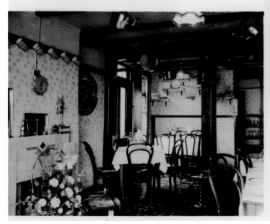

You are welcomed to

" **The Bellingham House** "

Restaurant & Guest House

HIGH STREET, TELEPHONE:
RAYLEIGH, ESSEX. RAYLEIGH 351

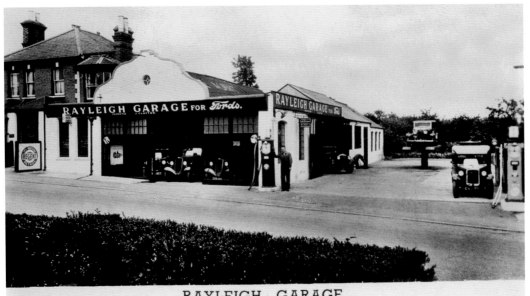

RAYLEIGH GARAGE

WEIR HILL,
RAYLEIGH, ESSEX
Phone :- RAYLEIGH 270

FORD AGENTS
OFFICIAL REPAIRERS TO A.A.

Rayleigh Garage and the Grange Service Station

We now view two postcards distributed by local garages. The top photograph shows the Rayleigh Garage in the High Road adjacent to the Weir ideally situated to catch the traffic on the A127. Have a look at the car in the background on the raised jack, the employee by the petrol pump and the early Rayleigh telephone number. The second card is from a later date as evidenced by the more modern cars. Located on the King's Highway along the London Road into town the Grange filling station remains although it no longer sells petrol.

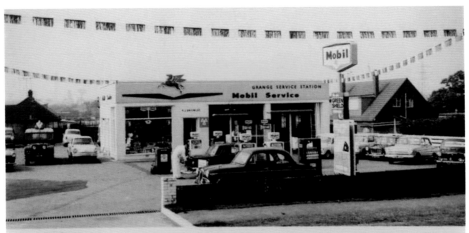

 GRANGE SERVICE & FILLING STATION
(P. J. KNOWLES)

247 LONDON ROAD, RAYLEIGH, ESSEX Tel. Rayleigh 6400
PETROL · OILS · SERVICE · REPAIRS · ACCESSORIES

SECTION 10
COMEDY

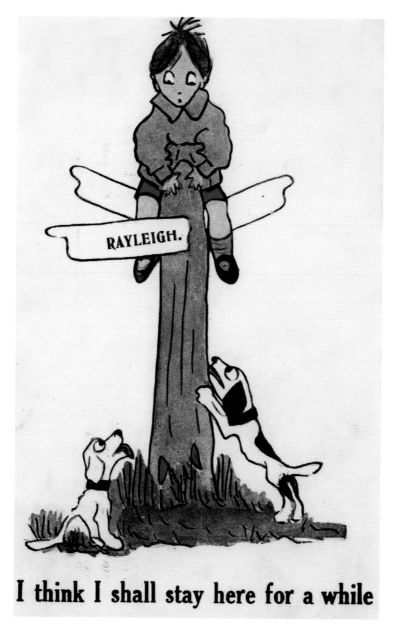

Rayleigh, I Think I Shall Stay here for a While

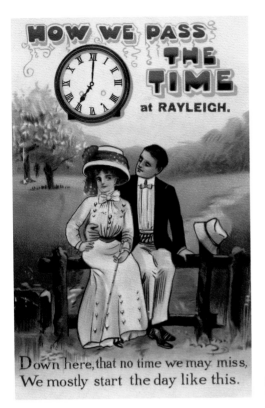

HOW WE PASS THE TIME at RAYLEIGH.

Down here, that no time we may miss,
We mostly start the day like this.

How We Pass the Time – 7 a.m. and Noon
In this section, we return to a bygone era of gentle humour mostly with a subtle play on words. The first six cards give an indication of how a young courting couple would spend the day. As each hour passes, we are working towards a crescendo with us wondering how the day will conclude at midnight! None show scenes of Rayleigh, all are imaginary.

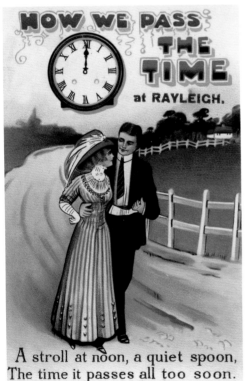

HOW WE PASS THE TIME at RAYLEIGH.

A stroll at noon, a quiet spoon,
The time it passes all too soon.

How We Pass the Time –
1.30 p.m. and 4 p.m.
These cards were produced in millions overprinted with the name of a particular town. It seems that the gentleman changes his attire regularly during the day as does the lady; indeed how they manage to have the time to meet in so many different locations is part of their innocent appeal and perhaps reflective of an era when clothes were changed to suit the occasion.

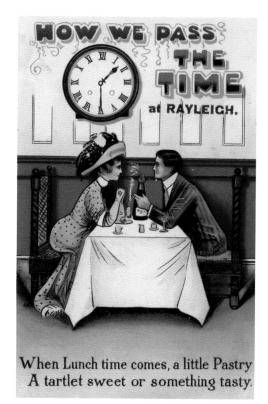

When Lunch time comes, a little Pastry
A tartlet sweet or something tasty.

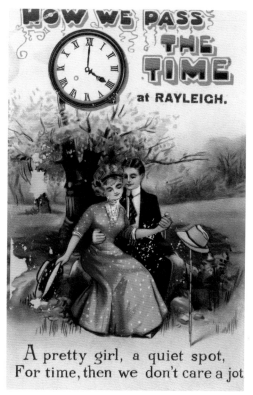

A pretty girl, a quiet spot,
For time, then we don't care a jot

HOW WE PASS THE TIME
at RAYLEIGH.

At gentle eve, when twilight lingers,
We don't let time slip through our fingers.

HOW WE PASS THE TIME
at RAYLEIGH.

At night time when the shadows fall
Then that's the sweetest time of all.

How We Pass the Time –
8.30 p.m. and 10.30 p.m.
All the six cards were manufactured in
Germany, dating them to pre–First World War,
use rhyming couplets including words such
as 'spoon', 'a quiet spot', 'twilight', seldom
used today. None of the six cards were sent
through the post, so we are left to wonder
who purchased them and for whom. Postcard
collecting was an extremely popular hobby
one-hundred years ago, and these probably
went straight into the owner's album.

Comical Birds

These two cards have a play on words with a bird theme, and I am sure that even today will raise a smile (or grimace) when viewed for the first time. The top card sent between two young girls was posted on Sunday 5 September 1915. Once again these cards were overprinted with the name of a particular town or village, and I have known collectors who specialise in these cards with different town names. I am sure there must be a collecting term for such collectors but will leave with our readers to suggest a suitable name.

Don't be a Goose
come to
RAYLEIGH.

Come to Rayleigh
and you will have something
to Crow about.

LOST! at RAYLEIGH
The fellow one to this

It was much attached to me

I'd had it for years

HANDSOME REWARD IF RETURNED IN GOOD CONDITION

There's no kid about it !

Tirohfeld Series Copyright No 452

Comical Footwear
This time we show some examples of the latest footwear available in the first decades of the twentieth century. The first is from a soldier on active service to his mother 'I shall be home tomorrow morning if I can obtain a pass'. The card travelled 30 miles and was no doubt received before the soldier arrived home. The second card was also sent locally, once again to a family member who was away from home for a short while. Cards of course for many were the only form of communication, very inexpensive and often delivered within twenty-four hours.

WE MISS THE PATTER OF YOUR LITTLE FEET AT RAYLEIGH

Time for Bed

Two more wonderful cards in this group both dealing with sleeping arrangements. The top card probably applies to many youngsters today including our own grandchildren. However, the bottom card is well worth a closer inspection. We can see the hole in the wall for the mouse, who is currently investigating the suitcase. The spider's web on the wall, the box of soft soap, but wait a minute how many feet are sticking out of the bed, with two people in bed each with a moustache! Such were the innocent times of yesteryear.

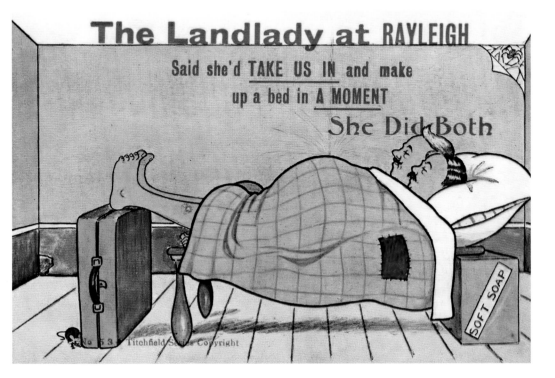

Many are called, but few get up at RAYLEIGH.

The Landlady at RAYLEIGH
Said she'd TAKE US IN and make up a bed in A MOMENT
She Did Both

SOFT SOAP

No 53 Titchfield Series Copyright

I came to **RAYLEIGH** for Change and Rest
The Railway Company took my Change,
And my Landlady has taken all the Rest !

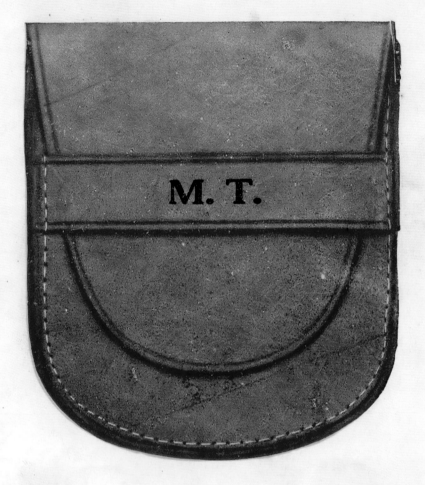

M. T.

My Money is all

dis- Pursed .

Where Did My Money Go?
This is the last card in this series and is full of hidden humour. Even the purse is 'M.T.'
(empty). The sender is a young lad writing to his mother in Colchester. He has just been
into Rayleigh to purchase the card, either from Frosts the confectioners or the Library, a
newsagents and tobacconists and sellers of postcards. However, the message on the card
states that he is not asking for money, which of course is not the inference on the front.